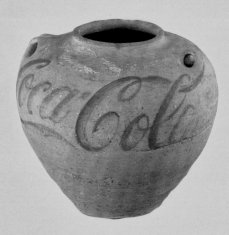

mahjong

ART, FILM, AND CHANGE IN CHINA

mahjong

ART FILM AND CHANGE IN CHINA

Introduction by Julia M. White

Essays by
Julia F. Andrews
Kuiyi Shen
James Quandt

Comments by Uli Sigg

UNIVERSITY OF CALIFORNIA, BERKELEY ART MUSEUM AND PACIFIC FILM ARCHIVE

This book serves as the catalog for the exhibition *Mahjong: Contemporary Chinese Art from the Sigg Collection* and accompanying film program at the University of California, Berkeley Art Museum and Pacific Film Archive.

EXHIBITION SCHEDULE

University of California, Berkeley Art Museum and Pacific Film Archive
September 10, 2008 – January 4, 2009

Peabody Essex Museum
February 14 – May 10, 2009

Published by University of California, Berkeley Art Museum and Pacific Film Archive, Berkeley, California

Available through D.A.P./Distributed Art Publishers
155 Sixth Avenue, 2nd Floor, New York, NY 10013
Tel: (212) 627-1999 Fax: (212) 627-9484

Book Design: Mary Kate Murphy
Editor: Judy Bloch

Perry-Granger & Associates Print Management
Printed in the United States of America

Library of Congress Cataoging-in-Publication Data
Mahjong : art, film, and change in China / essays by Julia M. White ... [et al.] ; with comments by Uli Sigg.
 p. cm.
 Catalog of an exhibition at the Berkeley Art Museum, Sept. 10, 2008-Jan. 4, 2009.
 ISBN 978-0-9719397-7-6 (alk. paper)
1. Arts, Chinese--20th century--Exhibitions. 2. Arts, Chinese--21st century--Exhibi-tions. 3. Arts and society--China--History--20th century--Exhibitions. 4. Arts and society--China--History--21st century--Exhibitions. 5. Sigg, Uli--Art collections--Exhibitions. I. White, Julia M. II. Berkeley Art Museum and Pacific Film Archive.
 NX583.A1M3412 2008
 700.951'07479467--dc22

2008019499

Opposite page
YU YOUHAN
Untitled (Mao/Marilyn)
2005

Page 2
YUE MINJUN
Sunrise (detail)
1999

Frontispiece
AI WEIWEI
Han Dynasty Urn
with Coca-Cola Logo
1995

Inside front cover
LIANG YUANWEI
Piece of Life
2008

Cover
GENG JIANYI
The Second Situation
1987

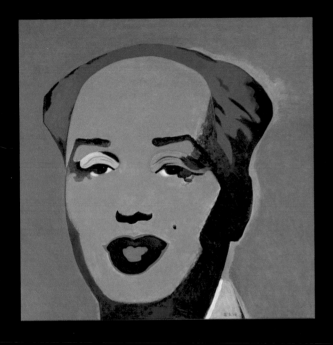

CONTENTS

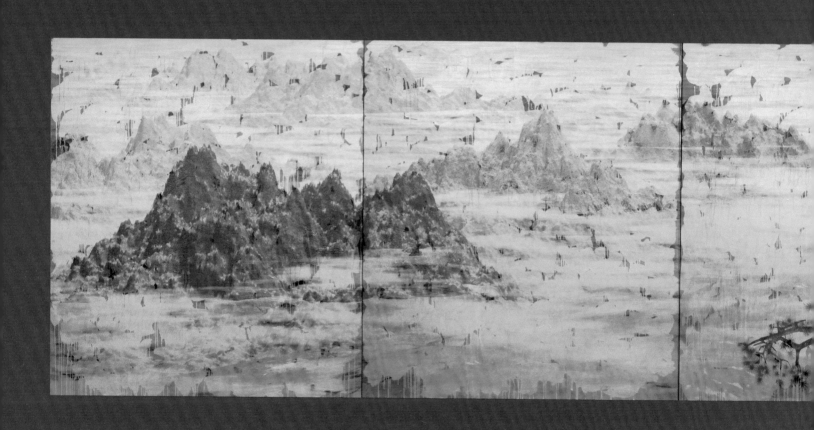

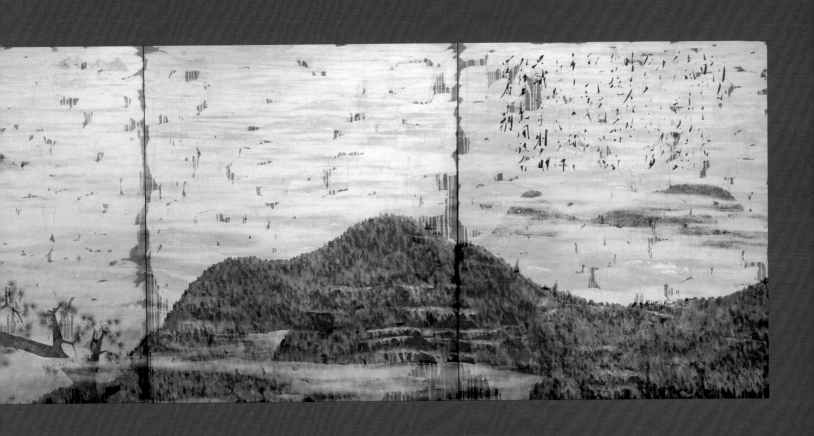

ACKNOWLEDGMENTS

QIU XIAOFEI
Song for the Motherland
2004

Previous pages
FENG MENGBO
2007WCSSXL01 (Wrong Coding Shanshui)
2007

First and foremost our thanks go to Uli and Rita Sigg for their extraordinary generosity in allowing us to show their unique collection of contemporary Chinese art at the Berkeley Art Museum. From the very beginning they provided support, enthusiasm, and guidance in forming the exhibition. Their gracious hospitality made our frequent travels to see the collection a delightful experience. We are also grateful to the two curators who initially brought *Mahjong* to the public in Europe: Matthias Frehner of Künstmuseum Bern, and Christoph Heinrich, formerly of Hamburg Künsthalle and currently curator of contemporary art at the Denver Art Museum. It was their initial exhibition that gave us the inspiration to bring the material to Berkeley. In Berkeley we have greatly benefited from the encouragement and support for the exhibition from Consul General of Switzerland Jean-François Lichtenstern and his wife Marylène.

We are fortunate to have had the initial introduction to the Sigg collection by sinologist and former dean of the UC Berkeley School of Journalism Orville Schell, and grateful for the guidance and enthusiastic support for the exhibition that Kevin Consey, former director of BAM/PFA, demonstrated from the outset. Their recognition of the importance of this collection and the impact an exhibition of this scope would have on the Berkeley community is highly valued, and we thank them for their involvement. Interim Director Jacquelynn Baas was equally enthusiastic about the project, and our newly appointed director Lawrence Rinder has seen to it that the exhibition has received the full support of the institution.

Many people contributed to the organization and presentation of the exhibition in Berkeley. We would like to thank Marianne Heller, Mr. Sigg's very capable assistant, and Yvonne Jaggi for their tireless work on behalf of the exhibition. In Berkeley we had the support of the entire staff of BAM/PFA,

with everyone contributing time, effort, interest, talent, and creativity. We would like to thank our director of registration Lisa Calden and her staff for their meticulous care in the details of a complex international shipment, working closely with packer and shipper Josy Kraft in Bern. Barney Bailey, chief exhibition designer, brought his many talents and his creativity to the design, layout, and presentation of the exhibition, and we are indebted to him and his staff for making this complicated exhibition look effortless in its presentation. We would also like to recognize and thank Kelly Seldan who worked with images and lists to create models in preparation for installation.

The film component of this exhibition was conceived of and executed by Senior Film Curator Susan Oxtoby and her staff. This additional dimension of work by talented filmmakers of the independent Chinese cinema was a component that only an institution like BAM/PFA, with its dual identity of art museum and film archive, could achieve. We congratulate and thank PFA for this inspiring program.

This catalog would not be possible without the contributions of our talented essayists Julia Andrews, Kuiyi Shen, and James Quandt. We thank them for their valuable insights into the art, film, and culture of China during the last forty years. We would like to thank Judy Bloch, publications director, and Mary Kate Murphy, director of design, for their diligence in the preparation and editing of the catalog. A great deal of organizational work was involved in its production, and we would like to recognize Grace Silvia, Stephanie Cannizzo, Xiaoyu Weng, Juan Xiong, and Christine Sheridan for their contributions to the book.

Director of Education Sherry Goodman, along with her staff, organized extensive high-level educational programs to accompany the exhibition, including an engaging series of conversations among noted artists, architects, writers, and China specialists. The Development team, headed by David Wheelan with support from Elisa Isaacson, Nancy Nelson, Frances Wocicki, Christianne Harder, and Sylvia Parisotto, utilized their many fund-raising skills to make this exhibition possible. In a wonderful spirit of collaboration, we had the powerhouse of international fund-raising Julia Hsiao and her colleague Amy Ambrose, both of whom offered valuable advice and support for the entire project.

Our sincere thanks to Carmen M. Christensen; to Barclay Simpson, President of the Board of Trustees, and his wife Sharon for their early crucial support of the exhibition; to Chairman of the Board of Trustees Noel Nellis and his wife Penny; to Trustee Tecoah Bruce and her husband Tom; to The W.L.S. Spencer Foundation and The Blakemore Foundation; and to the entire Board of Trustees of the Berkeley Art Museum and Pacific Film Archive for their trust, support, and commitment to this important project. Of course none of this would have been possible without Uli Sigg's vision of and commitment to preserving and presenting contemporary Chinese art.

Julia M. White, *Senior Curator of Asian Art*
Lucinda Barnes, *Chief Curator and Director of Programs and Collections*

Berkeley, California
June 2008

WANG DU
Stratégie en chambre
1998

INTRODUCTION Mahjong: Art, Film, and Change in China Julia M. White

Contemporary Chinese art and film have undergone enormous changes over the forty-year period from the Cultural Revolution to today. This transformation, at times glacially slow and at other times explosively fast, is represented here in artworks from the Sigg Collection and in the films of Jia Zhangke. The Sigg Collection is the largest collection of Chinese contemporary art anywhere, now numbering 2,000 pieces by 250 artists. The exhibition *Mahjong: Contemporary Chinese Art from the Sigg Collection* represents the historical span of art from the 1970s to today in China and demonstrates the dramatic evolution that has occurred, with artists exploring new materials and concepts far from what might have been imagined by even the most clairvoyant. As Chinese art emerged from the boundaries of state-sponsored and state-defined aesthetics to the complex initiatives of individuals with new intentions and motivations, it is possible to see the growth and development not only of art but of a nation.

The broad range of the work in *Mahjong* demonstrates the evolution of contemporary Chinese art and artists from an adaptation of Western realism of the Soviet style through many twists and turns to its current international idiom. A very few years ago, artists included in the exhibition would have been known only to specialists in the field, yet today a good many of them are recognized broadly both in China and throughout the United States and Europe. Much of this recent recognition can be credited to Uli Sigg and his persistent attempts to encourage Chinese artists and present their works on an international stage. In addition to collecting, in 1997 Sigg founded the Chinese Contemporary Art Award (CCAA) for artists living in China. In these pages Sigg reflects on his passion for collecting contemporary Chinese art and his understanding of the motivation of artists.

Of the nearly 100 artists featured in the *Mahjong* exhibition in Berkeley, many have been instrumental in bringing about significant changes in Chinese art. The early artistic leaders of the late 1970s and the 1980s were not only creating art, they were creating an environment for a new way of thinking about art. The exhibitions, public performances, and ongoing dialogue among these artists brought considerable resistance from the government, which in some instances endorsed or allowed exhibitions to go forward at state-controlled sites only to later cancel, and occasionally close them within hours of opening.

Among the first exhibitions of nontraditional Chinese contemporary art held in China, the so-called *First Exhibition of the Stars Group*, held outside the China National Art Gallery in Beijing in 1979, proved to be a watershed event for the emergence of a new kind of art in China. Two of the principal architects of that event were Huang Rui and Ma Desheng, who also brought about the formation of the Stars Painting Society (*Xingxing*) in 1980. The group, led by Huang and Ma, enlisted the involvement of Wang Keping and Ai Weiwei; all are represented in the Sigg Collection. Exhibitions of works by these and other artists of the early 1980s challenged the boundaries of what had been, as well as informed the art world of what could—and could not—be shown in exhibitions in China. The *First Stars Exhibition* was immediately shut down.

The images of Huang Rui's small oil on canvas *Yuan Ming Yuan* (p. 24) and Ma Desheng's untitled woodcut prints from the late 1970s (p. 22) are examples of new art trends that posed very different issues in an entirely different mode than the state-favored realist images of the Academy-trained artists. Typical of the work of the Stars group, these artists were interested in exploring Western artistic movements such as

surrealism, postimpressionism, and Abstract Expressionism. Wang Keping's sculptural images in wood, such as *Chain* from 1979 (p. 25), were the most politically charged works of the Stars group.

Huang Rui, Ma Desheng, and Wang Keping, like many of the Stars group, were self-trained artists not affiliated with any art school—Ma in fact had been refused entry due to a physical disability. Both Huang and Ma were young, just in their late twenties, and Wang was only thirty at the time of the *Stars Exhibition*. A number of the artists in the Stars group became, because of their actions and artwork, part of the diaspora of artists who left China, at least for a time. Huang Rui went to Japan but returned to live in Beijing and helped to found the now-famous Factory 798. Ma Desheng left China for Europe, as did Wang Keping, while another of the early organizers, Ai Weiwei, moved to the United States in 1981, returned to China in 1993, and now seems comfortable in both worlds.

Out of this initial foray and over the next ten years, artists were emboldened to create new art associations, providing exhibition opportunities for artists like Huang Yongping, Wang Guangyi, Gu Wenda, Zhang Peili, Xu Bing, and Geng Jianyi, among many others. Wonderful examples of early works by these artists are an important and unique aspect of the Sigg Collection. This generation was not anti-academic (the key aspect of the Red Guard art of the 1970s); rather, they were fascinated and absorbed with creating works that reflected their newfound knowledge of Western art. They were typically graduates of some of the top art schools in the country, such as the Zhejiang Academy of Fine Arts, and they also tended in these early years to identify themselves as part of larger groups, such as the Hangzhou Pond Society. The vocabulary of Huang Yongping's *Six Small Turntables* in mixed media from 1988 (p. 25) foreshadows the Dadaist approach to installation art (he was one of the founders of Xiamen Dada in the mid-1980s) that has made him an artist of high stature; his work has been included in international biennials in Venice and most recently in Istanbul, and has been shown frequently in Europe and America. Wang Guangyi's *Death of Marat* from 1986 (p. 26) borrows only the basic form from the eighteenth-century Western work of the same name and reduces it to a gray oil of postclassical proportions. In the same year the artist produced one of the most politically charged works of its time,

an oil of gray hues picturing a photorealistic portrait of Mao overlaid with a red grid, which redefined the cultural icon in a way that challenged both viewers and authorities (p. 28). Geng Jianyi's array of four faces entitled *The Second Situation* from 1987 (cover) and Zhang Peili's 1988 series of paintings of a pair of gloves (p. 27) are both somewhat troubling images for their underlying ambiguity about the human condition.

This decade of progress, through exhibitions, discussions, conferences, and articles, culminated in the exhibition *China/Avant-Garde*, organized in 1989 by art critic Gao Minglu and seemingly destined to open and close within a few days at the China National Art Gallery. That same year several Chinese artists, including Huang Yongping, were invited to participate in an exhibition of 100 artists at the Centre Pompidou in Paris; this would be the first time Chinese artists were exhibited along with other international artists. Huang Yongping went to Paris to install his work and never left, making his career and reputation in an international forum.

The exposure of new Chinese art to an international audience in Paris was just the beginning, an opening that was quickly followed by other significant firsts, with inclusion in such international arenas as the 45th Venice Biennale (1993) and the First Kwangju Biennale (1995). Group exhibitions in Europe and the United States, occasionally organized or curated by Chinese artists living abroad, introduced contemporary arts of China far beyond its border, making those outside of China more informed about the arts than those inside China. Yet there was resistance to this outside influence on art and artists. Yan Lei (in collaboration with Hong Hao) reflects this in *The Curators*, 2000 (p. 77), an image of real Western curators arriving in China to assess the "art scene." Through a false invitation to Chinese artists to appear in a fabricated section of Documenta X, Yan and Hong conspired to shed light on the influences these foreign arbitrators of taste had on Chinese art. In other words, not all artists were thrilled that a Chinese artist's reputation had to be built first and foremost on foreign acceptance.

At home, Chinese artists repeatedly tested the limits of expression and succeeded in presenting numerous exhibitions that included a wider range of arts than had ever been seen before. What became immediately clear from these exhibitions was that Chinese artists were not working strictly as painters;

by the late 1980s and early 1990s, many were exploring video, performance, and installation. Artists challenged the mythology of the past or icons of history in new media such as Song Dong's 1996 performance *Breathing* (p. 58), in which a simple, everyday function was turned political by the placing of his act and his art in the center of Tiananmen Square in a demonstrative fashion. Ai Weiwei's *Whitewash*, 1995–2000 (p. 15), used Neolithic storage jars in an installation that infers that the past can be eliminated by whitewash; in his 1995 *Han Dynasty Urn with Coca-Cola Logo* (frontispiece) he goes so far as to rewrite the past with a ubiquitous emblem of commercialism. In Wang Jin's 1997 *The Dream of China* (p. 63), the classical Chinese imperial robe is remanufactured not with silks but with the very reproducible plastic polyvinyl, a translucent material that may refer disparagingly to the past or to the present consumer-oriented world. The interest in word play and the historically valued tradition of Chinese calligraphy is offered new interpretation utilizing old media in the hands of an artist like Xu Bing in his nonsensical 1989 *Book from the Sky* (p. 25), or in Gu Wenda's *Myths of Lost Dynasties* from 1999 (p. 62), with its mysterious made-up character.

One of the most dramatic forays into new media came in 1992 with Zhang Peili's staged video *Water: Standard Pronunciation Ci Hi (Sea of Words)* (p. 66), which questioned the expectations of the viewer by appearing to present a real newscast but actually offering only the "talking head" reading a dictionary. Digging deeper into the question of what is real in the everyday, artists Ou Ning and Cao Fei created the 1999 video work *San Yuan Li* (p. 66), which takes the viewer for a close look at the backstreets of an ordinary town. Wang Jianwei's 1999 *Living Elsewhere* (p. 67) and Song Tao's *The Moment of One Shoot Another Dead* of 2004 (p. 66) expose the gritty side of urban life.

The artists of the 1990s and 2000s have expressed their work in a much more personal manner having to do with the challenges presented by a rapidly changing world. Artists like Zhang Xioagang in his oil-on-canvas *Red Child* of 2005 (p. 68) and Wang Jinsong in his photo series of 1996, *Standard Family* (p. 45), explore the evolving nature of family. Personal and societal demons haunt the world of many artists, from Fang Lijun's anguished figures from the mid-1990s (pp. 54, 55) to the repetitive laughing man of Yue Minjun's painting and sculptural

work (pp. 2, 52, 53, 74). A sense of how the dehumanizing state of contemporary life bears down on the individual in the workplace is created by Shi Jinsong in his torturous *Office Equipment—Prototype No. 1* of 2004 (p. 101). Urbanization, commercialization, and the struggle for identity are ever present in Weng Fen's photographs of a changing environment that picture a youth gazing into a real world, but one that is mutating so fast as to be beyond imagining (p. 94). These are the challenges and realities of modern China, which became the subject of the artists of the 1990s up to today. The earlier concerns of style, or of Westernism or modernism, fade away as the artist struggles to express his or her own reality.

In this catalog for the exhibition presented at the Berkeley Art Museum and Pacific Film Archive, essays by two observers from the academic arena illuminate these changes and the growth in Chinese contemporary art by tracing the history of the period. Dr. Julia Andrews skillfully elucidates the early period of growth from the 1950s to the end of the 1980s by describing how artists of this generation threw off the mantle of state rules and began to produce art that was relevant to the individual within society. This progression was by no means an easy or straight road to personal expression, and as Andrews describes the artistic climate during this period, it was clearly a time of turmoil, personal sacrifice, and political danger. Kuiyi Shen, in his essay "No U-Turn: Chinese Art After 1989," identifies the issues that concern artists of the 1990s and beyond, including their emergence from an underground existence into an international forum.

Andrews recounts how the state-sponsored introduction of socialist realism took Chinese art from a tradition that honored the sanctity of the brush for personal expression of "art for art's sake" to new demands that art serve the state through a formal idealistic representation that glorified the achievements of the masses. She traces the historical setting that artists of this generation endured under the strict Communist state. Relatively few examples of this work still exist as they were distributed out from the art schools to offices, auditoriums, and city halls to adorn the walls of these public spaces with images of state-sponsored and state-defined heroics. In the Sigg Collection one can see images rescued from obscurity that inscribe a political and artistic legacy that some would have happily erased.

The paintings of Guang Tingbo, with their idyllic rural settings (p. 21) or the image of a strong young cadre as seen in *My Name Is P.L.A. (Lei Feng)* from 1973 (p. 36), fit the needs of the state perfectly. Andrews points to the realist painter Wu Yunhua and his painting *From the Tiger's Mouth* (p. 20), and to Sun Guoqi and Zhang Hongzhan's painting (p. 21), which toe the political line in representing "the positive, the heroic, and the central." Sun Guoqi's image of *Chairman Mao with the New National Emblem* of 1973 (p. 37), painted with the same optimistic outlook as his work with Zhang Hongzhan, appears simplistic now. But at the time these works presented the image of the world as it should be, not necessarily as it really was.

Andrews pursues this theme in her description of the migration of painting to the woodblock print format that allowed for broad distribution of these images. The well-preserved examples of woodblock prints, as well as the numerous posters, that are on view are cartoonish in their bright colors and simple graphic quality (p. 23). This only better contributed to their function as visual tools to foster the policies of the state and the supremacy of Mao as the great benevolent ruler.

As Andrews so aptly describes, the situation of state control versus creativity led to the emergence of regional and local centers of production where artists looked to alternative means of expression. The optimism of the artists and their accelerated exploration of art in the mid-1980s led to what has come to be called the New Wave in Chinese art. Her essay takes note of the rise of exhibitions curated by artists and artist groups, which brought a breath of fresh air to the formerly state-controlled systems. Sadly, this blossoming of a new direction for Chinese avant-garde art was brought to an abrupt end in 1989 in the horrific events at Tiananmen Square.

In his essay Kuiyi Shen takes up the history of the remaining two and a half decades of China's artistic development, and again it is possible to see how closely interwoven are art, politics, tradition, and the state's overriding control of all facets of society. Shen rightfully points to the period as one of introspection among artists, who managed to hold on to some of the energy created during the emerging New Wave movement and began experimenting with a variety of new media, from photography to performance art.

A relaxation of controls created an environment in which artists disregarded traditional limitations of medium or materials and instead explored their own bodies through various radically untraditional ways. These self-exploratory works engaged topics ranging from consumerism to urbanization, and a reconsideration of the traditions upon which society rested. Shen explores these themes through the work of artists active in the late 1990s and into the 2000s and defines their artwork with a clear eye to the political and social transformations affecting modern China.

James Quandt explores the cinema of Jia Zhangke, who through a decade of work and a difficult life in China appears to have swallowed a bitter pill handed out by a government that allows for good and deserving people to feel utterly abandoned and left out of the new world of modern China. These themes of dislocation and alienation, often of young people in provincial outposts such as Datong, are made into visually compelling films that reflect on the futility of the individual when dealing with a state machine. Not unlike some of the artists in *Mahjong*, Jia cloaks his condemnation of post-Mao society with images of people struggling against the tide of commercialization.

Jia was born in 1970 in rural Shanxi Province to parents sent to work in the countryside during the Cultural Revolution. It is not surprising that Jia's work and the topics he tackles—"themes of globalization, fashion, and postmodernity"—converge with the artists in the Sigg Collection. Jia's Trilogy on Artists in fact includes a portrait of the painter Liu Xiaodong, an artist of tremendous technical skill as well as piercing insight into the human condition.

The presentation of Jia Zhangke's films alongside works from the Sigg Collection provides the opportunity to assess the developments in Chinese art in a continuous array of visually exciting avenues. From the saccharine-sweet heroic images of the Soviet Realist–style paintings and the ubiquitous "happy worker" of the Cultural Revolution to the rapidly expanding world of emerging artistic developments of more recent times, China and its changing social, political, and economic realities are brought into focus. Clearly, the only constant is change.

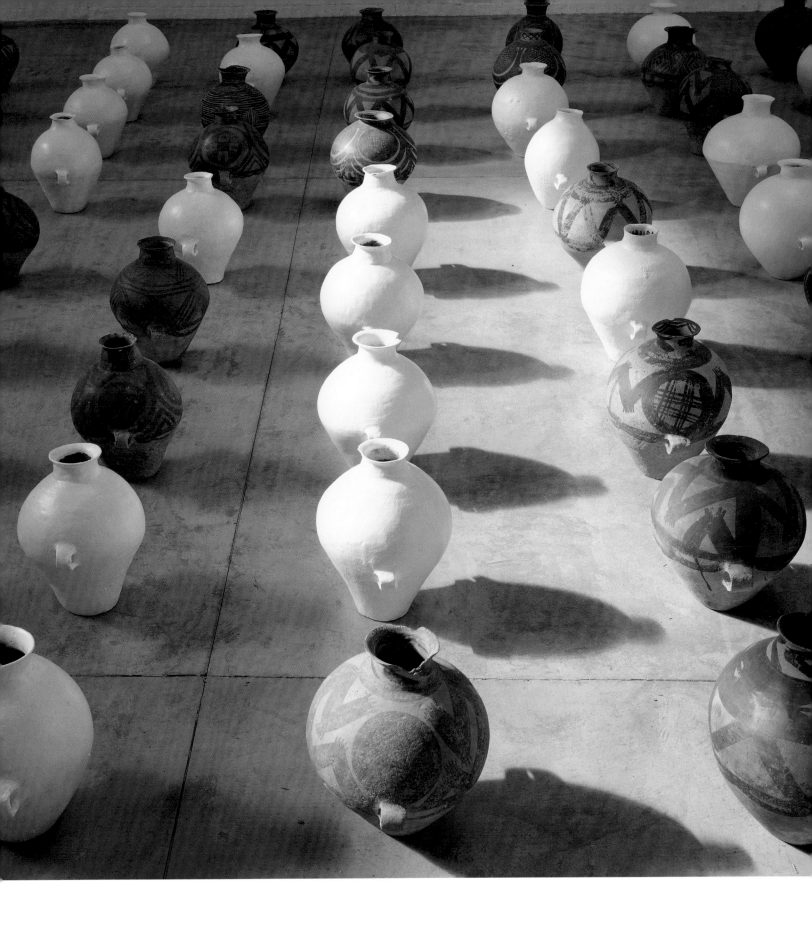

AI WEIWEI
Whitewash (detail)
1995–2000

Uli Sigg on Collecting Contemporary Chinese Art

Uli Sigg has a long and rich relationship with China and its arts. Sigg created the first joint venture between the West and China in the late 1970s, and returned to China in the 1980s as the Swiss ambassador to China and North Korea. The following are some of his recollections of collecting art in China.

I began collecting contemporary Western art early on. It was therefore a matter of course to explore contemporary art in my new environment when I first went to China, particularly since Chinese contemporary art had only just come into being with the "open-door policy" of 1978. What I saw at the time did not seem very interesting to a Western-trained eye. Those decades of being cut off from the mainstream of world art could not be eliminated in an instant. I consider these precursors of a really individual view extremely important for Chinese art history, but not of world status for experimental art. From the mid-1980s Chinese artists found an idiom of their own, and my interest grew.

I made my first purchases in the 1990s. I soon realized that no one—neither private individuals nor institutions—was collecting contemporary art even remotely systematically, either in China or abroad. Just imagine, here's a cultural area of huge importance, perhaps the biggest in the world, and nobody is collecting its contemporary art. I thereupon changed my focus and began to collect what Chinese artists were doing. I tried to cover the whole spectrum, across all media and styles. I am still doing that.

What I originally looked for was innovation from a Western point of view, but I had no luck with this absolute expectation. When I changed my focus to the overall view relevant to development—what had preoccupied artists

persuade his colleagues not to sell the works they exhibited to anyone who chanced along, but to be sure to keep them, because one day they could become very important. He forecast that this first big show of contemporary Chinese art would one day be a key event in art history. The artists objected—they had to earn a living! So Wang Luyan bought up his colleagues' major works himself. These are the ones I then bought from him, and they are available today, whereas all trace has been lost of many other works.

It was foreigners who made the market. The foreigners in China were basically business professionals or diplomats who had three- or four-year contracts or postings with a joint venture or the diplomatic service. They were not art collectors. More or less by chance they came across pictures they liked, and these probably now hang somewhere in an engineer's drawing room in Minnesota without the owners knowing that they are significant works of art. What is really regrettable is that these works can no longer be traced and are therefore lost, at least for the time being. Even the foreign gallery owners in the first phase had no access to major collectors and institutions. So it was not until the late 1990s that the first works reached prominent collections. That's also when the first Chinese collectors appeared, who at the time only ventured to collect oil paintings and sculptures.

In the earliest years, from 1979, visiting artists in their studios or homes was too risky for me. Collecting art at that time would have jeopardized my professional career in China and the success of the deals I choreographed as vice president of the first joint venture between China and the West. That joint venture became a model for China. It was intended to document to the West what is now a matter of course, but at that time was looked on as madness—that a Western company could invest in China and even transfer the latest

over a certain period—I had to revise my criteria. With every purchase I had, and still have, in mind to get a better hold of this totality and even define it for myself, an enterprise that is intellectually satisfying and destined to fail in equal measure. It is also obvious that at the level of individual work a certain degree of intensity, meaningfulness, and formal quality needs to be attained—the subjective dimensions. The mark of the good collector is then to choose the most significant works that happen to be available, and that is something that the viewer of a collection generally cannot appreciate. This changed focus also implies that not every work needs to be a masterpiece from a Western point of view. Often it's simply a particularly striking documentation of something Chinese.

In the 1980s there was no market, at best just occasional sales. I remember something that happened in connection with the first major exhibition of Chinese contemporary art in the National Gallery in Beijing, in 1989. It was symptomatic of the situation at the time. The artist Wang Luyan tried to

SHI GUORUI
Bird's Nest Stadium
2008

technology. That was of great importance for both sides, and to put that at risk by my personal passion for contemporary Chinese art would have been downright foolish. As a foreigner, one was conspicuous everywhere. But by the 1990s I was able to move around quite freely.

One aspect of collecting is no different in China from anywhere else in the world: to make a discovery, you have to look at ten trivialities. I've climbed thousands of steps in countless courtyards and made calls to no purpose. I met over a thousand artists. I bought directly from the artists almost without exception; it's only recently that there's been a gallery system. The art trade in China functions quite differently from that in the West. Quite a lot of artists always sold, and still sell, directly to collectors.

Moreover, meeting artists is extraordinarily important to me; it is the window to art and to China. Ideas surface that way, and in any case I look on many of the artists as friends. Even in the 1990s, it was an unusual thing for artists if a collector, or often anyone at all, wanted intensive discussions of this kind. It struck me time and again that artists were not used to presenting their work and talking about what they did. My questions often used to force them to think about it in a different way, and perhaps that is my most important contribution. I also make a point of standing up for the artists, and showing their works and lending them to my many guests, who now include directors and curators of some of the biggest institutions in the world.

From the viewpoint of my collection, two threads of development can be distinguished. I would call one of them world art, meaning accessible to anyone, without knowing any Chinese history. This covers works that have to do with basic human subject matter, pre-conceptual things. Art of this kind does not need to make any specific reference to China. Then there is a second thread: works that require some knowledge of Chinese history. If a work deals with the government's one-child policy and its consequences for the family and you know nothing about the one-child policy, you won't be able to understand the work in the way the artist intended. You can still like it, but for the wrong reasons.

As far as Western perception goes, the Chinese artists living abroad are very important. In the Western art world, they still represent Chinese art. Generalizing, we could say that Chinese artists living outside China engage in the issues of Western art debate and the requirements of the art trade much more intensively than artists in China. They often use a vocabulary of trendy Chinese characters and symbols for it, and are very successful with this approach. The artists living in China accuse them of playing the Chinese card. The diaspora artists counter this by saying that this was the culture they knew from their childhood and training, and they neither could nor want to disown it. But, whereas they tend to go for intercultural subject matter, artists in China are more interested in intracultural themes. My main interest is ultimately more in the art engendered within the energy field of China itself. That is not to disqualify the diaspora artists, from whom I have some works that are important to me—for example, by Huang Yongping, Xu Bing, Gu Wenda, Wang Du, and Zhang Huan.

When you have a look round the *Mahjong* exhibition, you'll get a feeling for what we try to pin down as "Chineseness." But it is extraordinarily difficult to capture this dimension conceptually. And the Chinese make equally heavy weather of it. Since, until recently, hardly anyone in China was seriously and systematically interested in the art that I have made the subject of my collection, one day a great chasm will open up in the country's collective memory. If the Chinese ask what artists have achieved since the end of the 1970s, it will be almost impossible to find an answer in China. A few institutions have works of official academic art, which until the end of the 1990s were exclusively painting and sculpture—a very narrow segment of contemporary art. Installations, video, and art photography are nowhere to be seen in these collections. At the end of the 1990s, you could count the number of Chinese collectors on your fingers—and even they limited their collections to the classic media of painting and sculpture. So I set about constructing the spectrum that was missing, with, at the same time, the aim of making official China aware of the gap. Should conditions exist that will allow for it, I would like to see my collection return to China and be exhibited there for the Chinese people to experience.

Adapted from the interview "Access to China: Uli Sigg in Conversation with Matthias Frehner," in *Mahjong: Contemporary Chinese Art from the Sigg Collection*, by Feng Boyi, et al. (Ostfildern-Ruit, Germany: Hatje Cantz Verlag, 2005).

LIU WEI
It Looks Like a Landscape
2004

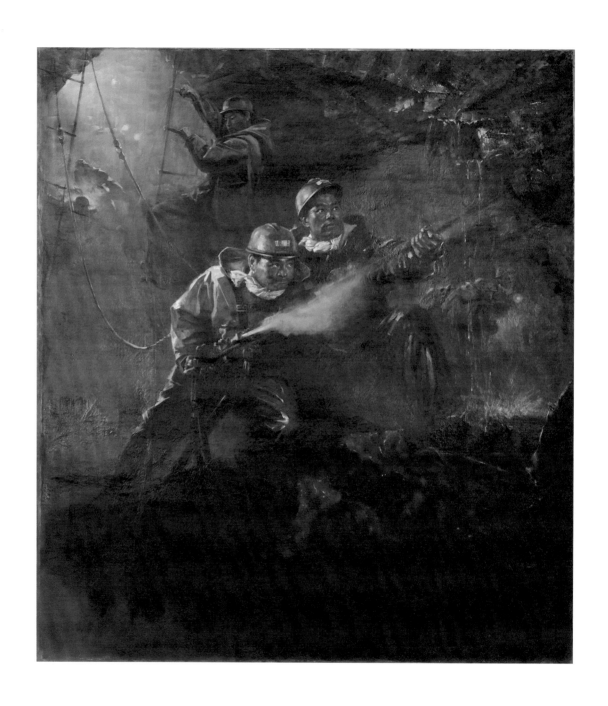

WU YUNHUA

From the Tiger's Mouth

1971

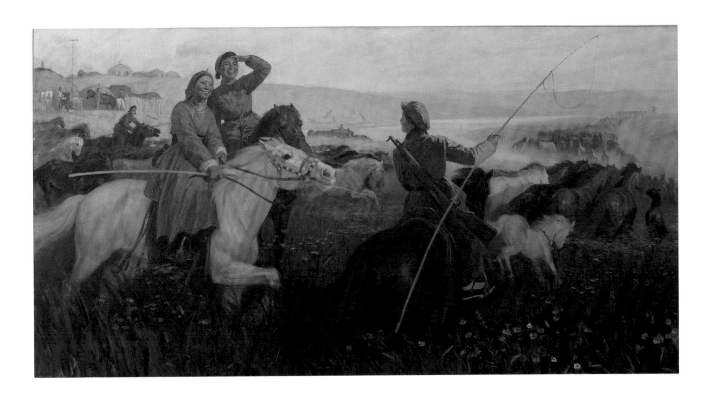

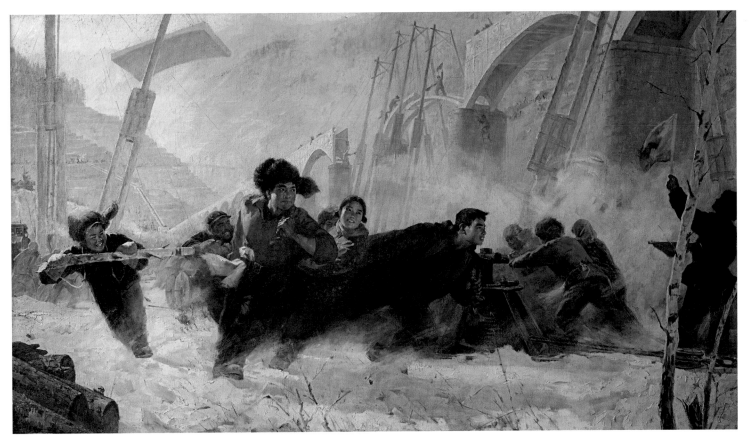

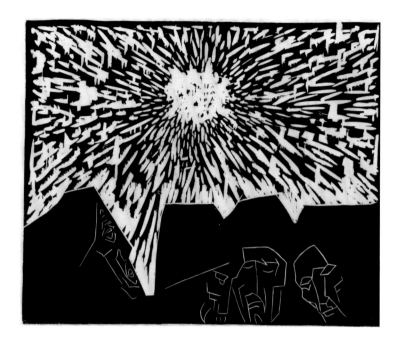

MA DESHENG
Untitled
1979–2005

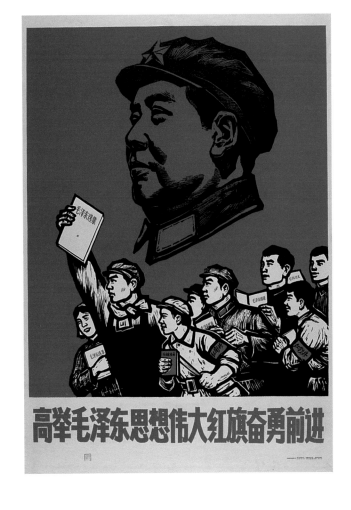

高举毛泽东思想伟大红旗奋勇前进

Propaganda posters
and prints from the
Sigg Collection

"Bamboo Shoot"
Not traditional
subject - heavy impasto
canvas - not stretched
wavy

UANG RUI
lan Ming Yuan
'79

FENG GUODONG

Guang He (Yellow River)

1979

ZHU JINSHI

Bamboo Shoot

1979

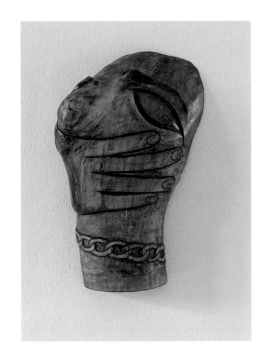

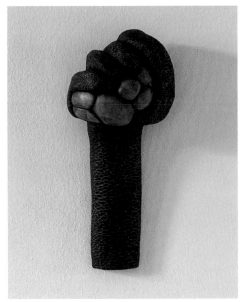

WANG KEPING

Chain

1979

XU BING

Book from the Sky

1989

WANG KEPING

Fist

1981

HUANG YONGPING

Six Small Turntables

1988

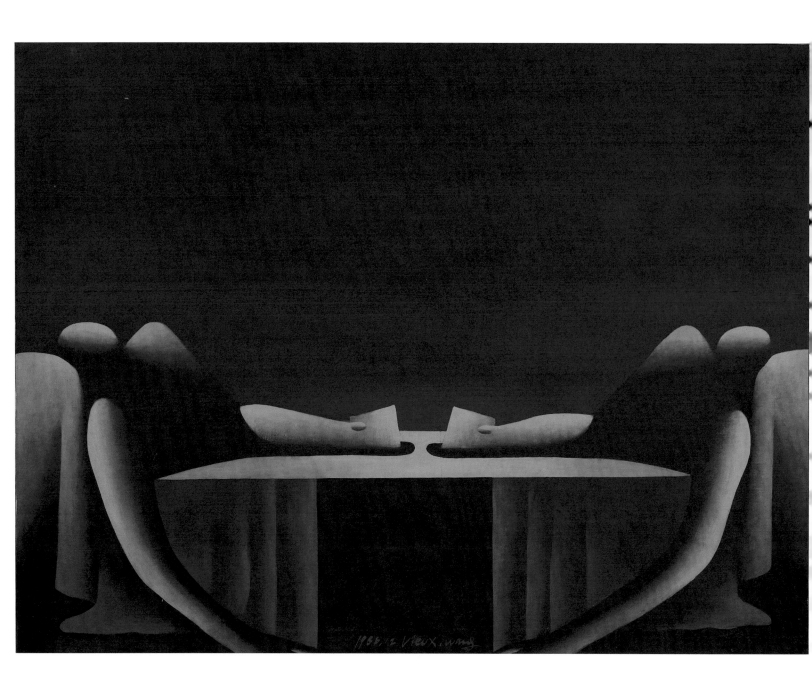

WANG GUANGYI
Death of Marat
1986

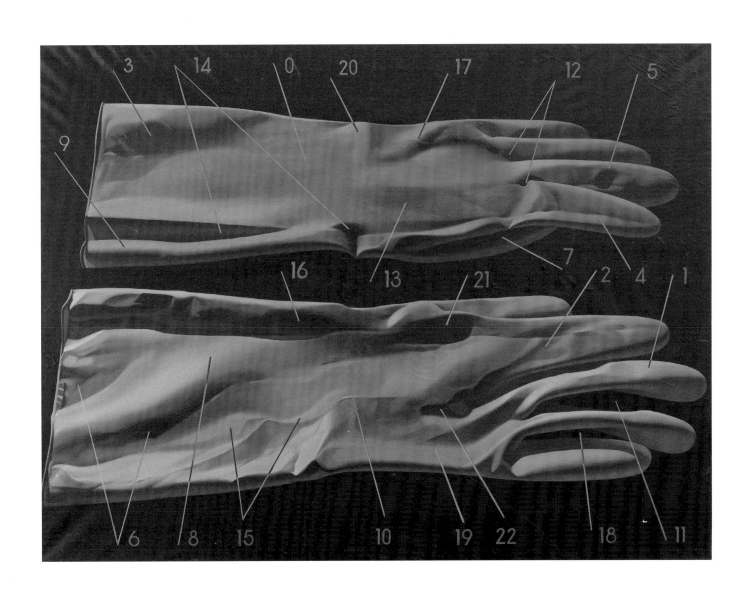

ZHANG PEILI
Untitled
1988

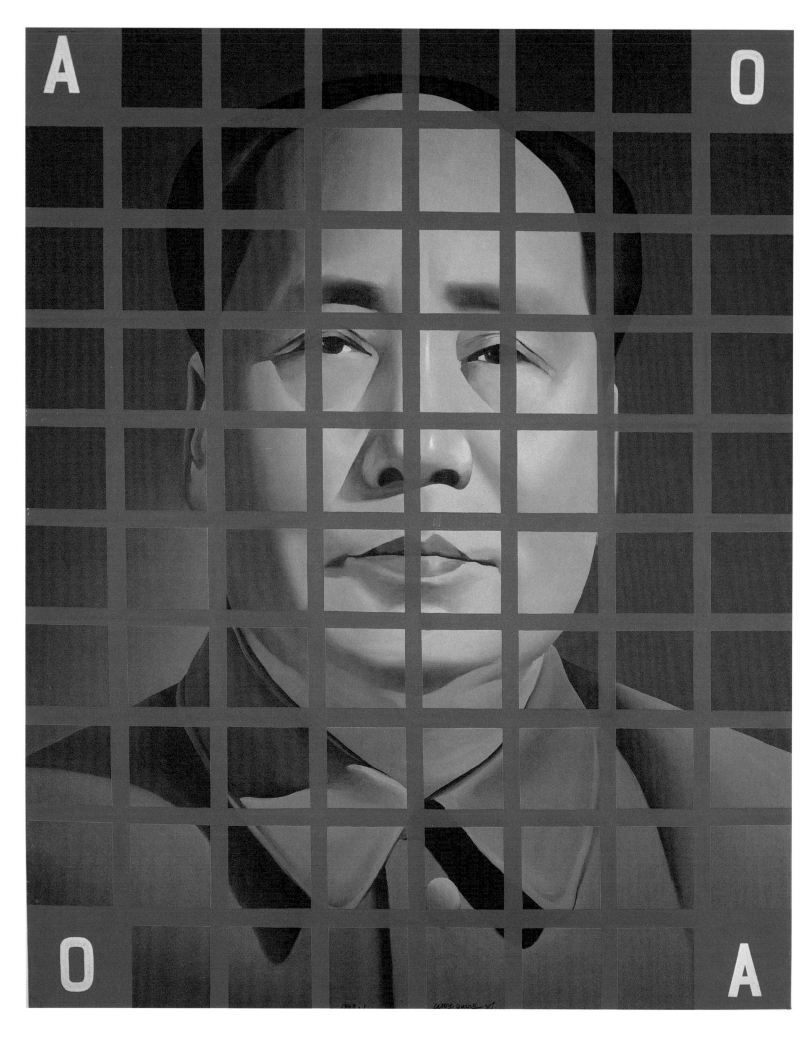

Post-Mao, Postmodern Julia F. Andrews

The development of contemporary Chinese art, particularly that of the 1980s and 1990s, was inextricably linked to the art and culture of China's Maoist past, most notably the artistic, social, educational, and political culture of the Great Proletarian Cultural Revolution (1966–76). This complex and sometimes horrific political convulsion sent an entire generation of young people out onto the streets between 1966 and 1968 to write banners, paint slogans, and draw cartoons and portraits in support of Mao's new revolution. Beginning in 1968, their usefulness to this purpose exhausted, they were sent for reeducation to the countryside, where they labored alongside rural peasants on small plots of communal land, or with soldiers in vast military farms.

The foundations of this movement were established in 1942, when Mao Zedong (1893–1976), then leader of the Communist armies based in Yan'an, Shaanxi, delivered a series of talks that prescribed the role of artists and writers in building a new Communist society.[1] In simplest terms, artists were to become cogs in the revolutionary machine, to abandon self-expression and artistic freedom, and to cast aside such ideas as humanism, liberalism, or individualism as intellectual justifications for their creative work. "Art for art's sake" was specifically condemned. Artists were to serve the people, particularly the workers, peasants, and soldiers. Those who joined the Communist army in wartime, and remained with the Communists after the peace, accepted the appropriateness of Mao's formulation, creating large numbers of didactic and propagandistic woodblock prints in support of both the Chinese war effort and the social, educational, health care, and land reform policies of the Communist base area's administration.

With the 1949 Communist victory in the civil war that followed Japan's surrender, Mao's cultural program was implemented nationwide. By 1953, the Chinese Artists Association had been established on the centralized Soviet model, and an official art bureaucracy put in place. With socialism, almost everyone in the workforce was shifted to a state job, and the selling of art for money was gradually phased out. A new system of state sponsorship replaced private patronage. It completely controlled formal artistic training, exhibitions, and publications of art; laid out a party-determined political or ideological function for art; and mandated the "socialist realist" style, which was loosely defined but explicitly antimodernist.[2] It was also antitraditional.

Indeed, the arts officials charged with remaking China's art world considered both modernist oil painting and traditional Chinese painting, especially that of the literati, "art for art's sake," and therefore made a determination to eliminate it. Instead, they instituted a policy that had been suggested by a few prominent philosophers during the iconoclastic years following the overthrow of the emperor in 1911: that Chinese painting be replaced by Western realism.[3] At the same time, the practices of the Yan'an era, and particularly the mandates of Mao's Yan'an Talks, were seen as integral to the spirit of the new art. In practice, as Arnold Chang has pointed out,[4] this yielded an episodic alternation between the two poles of Mao's thought: periods of "raising standards," which favored oil painting, and "popularization," which favored folk art, woodcuts, cartoons, propaganda posters (*xuanchuanhua*), and village mural painting. By the end of the Cultural Revolution, and particularly between 1971 and 1979, the two were combined, as realist oil paintings were supplied with slogans and reprinted as posters, thus converting high-quality painting into a popular form that could be disseminated to the masses (p. 23).

WANG GUANGYI
Untitled
1986

Although the authorities offered old artists some opportunities to remold themselves, the new art and the methods for teaching it were largely developed by the younger generation, those trained under the new policies. In 1955, a Soviet expert, Konstantin Maksimov, was invited to Beijing to teach the principles of socialist realist oil painting to an elite class of students from all over China. His students, who graduated in 1957, went on to set the standards for the next generation.[5] Shortly thereafter, artists who had traveled to study at the Repin Art Institute in Leningrad began to return home, bringing with them other authentic models from the very source of socialist orthodoxy. With this elite education, a new world of "fine arts" was created, ultimately based upon European academic standards, as transformed by the Stalinist apparatus in the U.S.S.R. Artists were of high social status, and their fame was granted by the party in the form of exhibition opportunities, publications, prizes, and commendations.

Virtually all images produced in this context were extremely readable, often telling a story. Portraits of Mao Zedong and other leaders were frequently set in a particular historical moment; a vast corpus of such images successfully constructed (and sometimes fabricated) a history of the new nation that focused almost entirely on the deeds of early Communists. Explicitly narrative paintings glorified the self-sacrifice of revolutionaries of the past and those in recent times who resisted China's enemies, including American imperialists in Korea. Gloomy images portrayed the sad state of the old society in implicit contrast to the glorious brightness of the socialist present. Following the terrible famines of 1959 to 1961, efforts to comfort the populace (and hide the reality of the regime's failures) appeared in the form of socialist realist images of happy workers, peasants, and soldiers. By this time, ink painting had also been completely remolded, so that its imagery and socialist realist style were very similar to those seen in contemporary oils. As is standard in socialist realist imagery of the U.S.S.R. (as well as in American superhero comics), the viewer must gaze up at the heroic farmer, whose stature is thus transformed from poverty and oppression into confident self-possession. Although intensely propagandistic in intention, and now known to be false in content, the accurate details of clothing, setting, and attributes made these works convincing representations of the new prosperity of the peasants. Censorship of news was very effective in hiding the truth, and few people then knew the extent of the deprivation suffered by China's rural population in Mao's ill-conceived Great Leap Forward of 1958. Thus, it was these happy images of a benevolent ruler and uplifting society that imprinted the minds of China's schoolchildren with the virtues of public-spirited behavior in the cause of building the new Communist China.

The Cultural Revolution, which we now know was engineered by Mao to purge his rivals in the party, was launched in the spring of 1966, pulling the enormous postwar generation of adolescents out of school and into the streets in a mass mobilization, which they believed called them to realize in practice the socialist virtues with which they had been nurtured. The Red Guards set forth to combat the "Four Olds" (old customs, old culture, old habits, and old ideas) and all class enemies who might oppose Mao's view of revolution. Unsullied by the taint of life in the old society, it was imagined that they alone were prepared to bring the Maoist utopia into its most complete form.

To match the purity of this mission, at least in the most heated days of the movement, in 1966 and 1967, the Red Guards adopted the woodcut—the vehicle by which the Yan'an revolutionaries had taught their values to the peasants of northern Shaanxi. Though the most commonly reproduced of these prints, which became ubiquitous icons of the Cultural Revolution, were executed with more technical finesse, they are similarly bold and simple in composition and message. The Red Guard artists sought to achieve revolutionary effectiveness through such rustic simplicity.

The history of the Cultural Revolution has been periodized in various ways. Bonnie S. McDougall described its three epochs as: Cultural Revolution proper (1966–69), the transition (1969–71), and the recovery (1972–76).[6] The first yielded vast numbers of ephemeral Red Guard posters and newspapers, as we have seen. In the second, most artists, young and old, were engaged in hard labor. However, in 1970, work was begun at the national level to organize a national art exhibition, and many local administrations set up "creation teams" to produce model paintings in the new Cultural Revolution manner. The ultimate arbiter of style was Mao's wife, the retired Shanghai actress Jiang Qing. Now, a small number of academically trained

artists were brought back to the city from their reeducation in the countryside to advise, assist, and correct the creative efforts of the workers, peasants, and soldiers—aspiring artists among the rusticated youth and former Red Guards—so that their work might ultimately be featured in the provincial and national exhibitions.

A dramatic iconographic shift occurred after September 1971, when Mao's chosen successor, Lin Biao, was killed under mysterious circumstances. The deadly rift between these model comrades-in-arms broke the Maoist spell that had overtaken many of China's youth. The artwork produced in the final period of the Cultural Revolution was far more academic than that of the chaotic, revolutionary early years of the movement, and was intended less to persuade the public than to gain approval from the authorities. Hindsight makes evident the highly restrictive context in which these artists worked. The bombastic yet empty claims of the political apparatus for which they were mobilized inevitably betrayed their zeal, but nevertheless produced a large, highly talented, if eventually disillusioned generation of artists.

In this third period, after partial reconstruction of the cultural bureaucracy, a series of national exhibitions was held under the auspices of the State Council's Culture Group. If these exhibitions demonstrated a return of social order to China, they also exemplified the most extreme degree of central organization in cultural production and uniformity of socialist realist style ever seen.[7] In response to Jiang Qing's taste, artists combined Soviet socialist realism, the bright, sometimes excessive colors of China's folk traditions, and a slickness of execution that can only be associated with the Shanghai commercial art, particularly movie posters, of Jiang Qing's youth.

Beyond stipulations about artistic style and about the artists' backgrounds—namely that worker-peasant-soldier artists were to be given priority—regional, local, and generational concerns were also of great importance in this era. In Liaoning, for example, a creation team engaged young art school graduates Wu Yunhua, Guang Tingbo, and others to make work of particular relevance to their northeastern home. Wu Yunhua, a 1968 graduate of the Lu Xun Academy of Fine Arts in Shenyang, was assigned to the provincial creation team in 1969. During that period he spent three years in the northeastern coal-mining region of Fushun and thus, in his paintings for the 1972

exhibition, could utilize his local experience to depict socialist realist icons. *From the Tiger's Mouth* (p. 20), in which heroic copper miners attack dangerous rock walls with pneumatic drills, utilizes the highly theatrical illumination and the melodrama of socialist realism to elevate Chinese miners to a position of glory almost akin to that of their leader. Despite the highly stereotypical and artificial way in which the subject is rendered, the artist is considered to have brought an authenticity and authority to the gallery that is based upon his own personal observation. Artists were taught to be true to what they saw, to find compelling subjects from their own experience, but to then manipulate their observations according to the "three prominences": the positive, the heroic, and the central. Works from the northeast, therefore, emphasize heavy industry, as well as the extreme hardships of labor in the frigid Chinese territory near the Siberian border. In an almost ludicrously melodramatic scene prepared for the 1974 *National Exhibition to Commemorate the Twenty-fifth Anniversary of the People's Republic of China*, two of Wu Yunhua's colleagues, Sun Guoqi and Zhang Hongzhan, rendered with extraordinary revolutionary zeal their comrades who built an aqueduct in the bitter snow and wind of the Manchurian winter (p. 21). The fervor of the pink-cheeked heroes seems to provide an inner heat that will protect them against the elements.

The art itself, the art exhibition system, and the widespread reproduction of paintings as posters were extremely important in reestablishing, particularly for the new generation of artists, stable patterns of engagement between the makers of art, the official system of rewards, and the public who viewed paintings and hung posters on their walls.[8] For the reestablished bureaucracy, the national exhibition system, with its process of jurying and selection, became the professional framework for identifying and accrediting artists, a structure that exists, in a much less authoritative position, even today.

Reception of mass-media versions of the Cultural Revolution exhibition paintings may be difficult to document, but anecdotal accounts suggest that the romanticism of this style succeeded in filling the hearts of susceptible young Chinese viewers with the utopian fantasies the artists so skillfully depicted.[9] Certainly, standard works were reproduced and seen in meeting halls and public spaces all over the nation (as depicted in Shao Yinong and Mu Chen's photographs on page

95). Whether the emotional appeal of gazing at the strong, healthy, and resolute girls and boys in the posters was purely political, as intended, or something quite different, these models nevertheless formed the mental imagery of a generation of Chinese.

From the artists' perspective, vivid authentic personal experiences lay behind many of these creations, even though the end results were dramatized or even fictionalized versions that accorded in style and subject with the wishes of the authorities. For many, these national exhibitions represented the first acknowledgment that they were artists, and were the beginning of a new way of life and of thinking about themselves. A great many of them were rusticated urban youth, and when they made their way back to the cities with this newly privileged status, they were no longer Mao's children but grown-up professional artists.

Stories of the punishments ordinary citizens received during the Cultural Revolution for unthinkingly desecrating an image of Mao when reusing a newspaper or engaging in other daily activities abound. If participation in the national exhibitions was a positive incentive to contribute to the new culture, punishment and public humiliation reinforced conformity with the new styles, iconography, and cultural practices. Mao's death in 1976 did not immediately disturb this system, although it changed its iconography; by 1978 and 1979, the benevolent deeds of the late premier Zhou Enlai emerged as a frequent theme.

Although Western observers watched with anticipation for signs of political dissidence in art, some of the most potent exhibitions of that period can only be understood for what they were *not*, direct expressions of political opinion. By 1979, while the national system continued as though on autopilot, local cultural centers began exploring alternatives to socialist realist art. In search of creative freedom, artists who ran exhibition spaces, such as district cultural palaces, began holding exhibitions of apolitical oil paintings—usually flowers or landscapes—that harkened back to a pre-Communist urban art world, and thus were powerful, if intentionally indirect, comments on the previous decades and on China's future artistic direction. Elderly pioneers of postimpressionism exhibited alongside eager youngsters, all sharing the exuberance of their newfound creative freedom.

Certain practices of the pre-1949 period, most notably modernist abstraction and the academic practice of painting the nude, were also revived, but because they still remained extremely problematic for party authorities in the early 1980s, artists who exhibited such work often found it censored. Central Academy of Fine Arts graduate and former Rightist Yuan Yunsheng is an uncompromising personality who pushed the art world from inside with a daring mural at the Beijing airport in 1980, only to have it boarded over. A group of amateur artists, the Stars (*Xingxing*), challenged it from outside. In September 1979, right before the national exhibition to mark the thirtieth anniversary of the P.R.C., the group hung their amateur oils, woodcuts, and sculptures, which included images of nudes and ruins, on the fence outside the China National Art Gallery (*Meishuguan*).[10] Their emphasis on negativity and decay, and on individual angst, was in obvious contradiction to the happy propaganda of the Cultural Revolution.

Stars artists Wang Keping (p. 25), Ma Desheng (p. 22), Huang Rui (p. 24), Qu Leilei, and Yan Li were among the earliest to straightforwardly address the psychological effects of Cultural Revolution policies on the souls of their countrymen. Although most of their work was not political in any normal sense, their very rejection of political subject matter, and of Mao's ban on bourgeois liberalism, was a political act.

Moreover, the Stars were aware of a similar unofficial or unapproved exhibition held a decade earlier in the U.S.S.R. that became internationally notorious when it was destroyed by bulldozers. The young Chinese, then, explicitly challenged the organizational structure of the party-controlled Chinese art world. Their first show was, predictably, closed by the authorities, but the recently rehabilitated and reappointed arts administrators, who were undoubtedly sympathetic to the young artists' criticisms of Mao and the Cultural Revolution, responded by trying to co-opt them rather than punish them. The Stars were granted official exhibition spaces for two subsequent exhibitions, and it was not until Wang Keping made a late-night switch to the approved checklist, installing a satirical sculpture of Mao, that this endeavor ended. A positive evaluation of their efforts by youthful art critic Li Xianting that was published the following year led to his dismissal from the party journal *Art (Meishu)* during the anti-Spiritual Pollution campaign of 1982 to 1984.[11]

While rejecting the Cultural Revolution, and beginning tentative steps toward modernizing the economy, the party authorities in the early 1980s were reluctant to liberalize artistic expression. Sale of art by individuals still remained very much taboo, if not illegal, so the only legitimate patron for art remained the state. During this time, however, art institutions began acquiring publications about contemporary foreign art. If work in such styles could not yet be easily exhibited, prohibitions of private experimentation were somewhat relaxed. The library of the Zhejiang Academy of Fine Arts (now China Academy of Art), for example, acquired a particularly good collection of books and magazines on contemporary international art, a move that some graduates and former instructors believe helped its alumnae assume leading positions in the '85 New Wave Movement.[12] According to Gu Wenda, who was a graduate student there in the early 1980s, interest in Western modernist and postmodernist work became a self-sustaining current within the student body, passed on from one class to the next without much direct influence from the faculty or school administration. In this same era, publishing houses began new translation projects that introduced a diverse array of Western philosophical texts, as well as books on art theory and art history, to Chinese readers. Western theory and philosophy, particularly those of Freud and Sartre, were particularly appealing to art students in this early period.

The new atmosphere in the art world resulted at least in part from changes being made throughout the Chinese bureaucracy in 1985. In a speech on October 22, 1984, national leader Deng Xiaoping declared the particular importance of promoting talented young people into administrative positions; other party leaders called for creative freedom. If young artists, particularly those at the art academies, had already begun experimenting in international forms of art, it is not surprising, given the comparatively liberal tone of official writings in 1985, that the new art and the critics who sought to explain it garnered sufficient institutional support to bring these new forms of art into the light. An official art conference, held at Huang Shan in Anhui in April of 1985, began the process of redefining official standards of art.[13] Perhaps most significantly, the group concluded that politics should be abandoned as the purpose of art, that the bonds of a narrow "national style" be broken so that artists might pursue an international idiom,

and that Mao's rejection of modernism be reconsidered. Yan Li had exhibited a number of surrealist works in the Stars exhibitions, including his *Dialogue* of 1980, a work with a 1920s or 1930s flavor. More elaborately structured surrealist works that enabled young academy graduates of the 1980s to demonstrate their excellent technical training, albeit with a modernist twist, began appearing in official exhibitions as early as May of 1985.[14] By summer, the graduation exhibition of the Zhejiang Academy of Fine Arts, previously a venue for thematic, political "creations," showed a number of works that dealt with the most mundane, alienated, or pessimistic aspects of the young artists' lives. In December, with sponsorship of the local branch of the Chinese Artists Association, Zhang Peili engaged fellow Zhejiang alumnae in the *'85 New Space Exhibition*, which exhibited fifty-three examples of similarly blasé or ironic work in the school's gallery.

At the same time, the China National Art Gallery agreed to rent its space to the American Pop artist Robert Rauschenberg in November 1985 for his ROCI (Rauschenberg Overseas Cultural Exchange) project. Such a show would not have been permitted in earlier times, for even in the early 1980s classics of Western abstract art had been a cause for dispute between American and Chinese curators. The mounting of Rauschenberg's show, then, is testimony not only to new economic policies but also to the new cultural policies of the moment. The weekly *China Art News* devoted a December issue to coverage of the show.[15]

This exhibition had a profound impact on young Chinese artists who strove to work in an international language. Many of Rauschenberg's works incorporated found objects from his various international travels. Although the unsympathetic might argue that his use of local objects has no deeper cultural significance than a sort of touristic souvenir collecting, these Chinese artists apparently found it a useful challenge. The show awakened them to the possibilities of their own environment, which they understood better than any foreign artist might, as a source or subject for contemporary cosmopolitan art. Within a few weeks of seeing the exhibition, artists of the Three-Step Studio in Taiyuan, Shanxi, attempted to hold an exhibition that involved found objects from their locale. Although the exhibition was closed by the authorities, it became known to the Chinese art world through published photographs of the installation. During the following year,

quite a large number of young painters began experimenting with installations. The national art press, whose recently hired young critics were extremely ambitious in promoting the open-door policies, avidly published descriptions and reviews of these shows.

Xiamen Dada, a group of which the Zhejiang Academy graduate Huang Yongping was the best-known member, attempted to hold an exhibition of objects found around the Fujian Provincial Art Gallery in late 1986. Closed by the authorities, the activity nonetheless satisfied the artists, who aimed to come to the gallery empty-handed and leave the same way. This event marked a turning point for many young artists, including the painter Huang Yongping, who has subsequently worked almost entirely in multimedia installations.[16]

Rather than carrying the world into the gallery, the Hangzhou artists took their installations out into the local community. A group of painters that called itself the Pond Society, composed of Zhang Peili, Geng Jianyi, and several others, pasted their first installation, *Master Yang's Shadow Boxing Series*, on a wall near the lakeside Zhejiang Academy on June 1, 1986. Made of cut newspapers and blueprint paper, the work consists of twelve figures performing the gestures of the Chinese meditation-exercise Taijiquan; each is labeled according to the standard textbook moves. Passersby would enter the artists' artificial world as they rode their bicycles to work. The cutout figures possess some of the ghostliness of George Segal's life-sized plaster renderings of mundane human activity.

The Pond Society's work resonates with undertones specific to its Chinese context. Pasting unapproved papers on walls is fundamentally an act of vandalism, and China's quite recent oppressive past probably made the potential illegality of this work more startling to viewers than a similar piece would have been in New York. Walls around compounds, moreover, were until recently a particularly characteristic part of the Chinese environment. During the Cultural Revolution they served as places to paint slogans, glue notices, and hang propaganda. This installation, with its traditional Chinese subject matter, seems to play with juxtapositions of the present and the past, the old and the young, and art and society, but it is even more ambiguous because of its particular physical, social, and historical context.

By summer of that year, the young artists and critics had moved beyond their status as guests at the official table and had organized their own national event, a conference held in August at the newly established Zhuhai Painting Institute, where Zhejiang graduate Wang Guangyi had moved as an administrator. Wang Guangyi's painting *Death of Marat* of that year exemplifies the interest in surrealism of many of his colleagues, but with his own particularly ambiguous reference to or rejection of classical traditions (p. 26).

The conference brought together faculty from China's national art colleges, editors of major art journals, officials of the Chinese Artists Association, and some young artists.[17] The organizers, led by Wang Guangyi, suggested that a mechanism be developed for guaranteeing representation of the New Wave artists in the national art exhibitions, which would thus bring them into the official art world. Following these discussions, a decision was made to hold a separate national exhibition of New Wave art. The Zhuhai conference of August 1986 thus was the beginning of an organizational structure by which the avant-garde or the New Wave might claim institutional legitimacy within the power structures of the official art world.

The comparative ease with which the movement was launched, and its widespread official support in 1985 and 1986, did not continue. Student demonstrations that broke out in the fall of 1986 were blamed on bourgeois liberalism. Another cultural crackdown began that lasted throughout 1987, and it was not until the summer of 1988 that dreams of holding a modernist or New Wave art exhibition were once again considered viable. With the pattern of on-again, off-again liberalization, pent-up enthusiasm combined with a sense of urgency as practitioners and supporters of the New Wave sought to take advantage of the possibly short-lived window of opportunity. In 1988 the China National Art Gallery, which had hosted the Rauschenberg show three years before, mounted its first exhibition of postmodern Chinese art, Xu Bing's *Book from the Sky*, an installation of Song-style books and hand-printed texts using his unintelligible lexicon of fake characters (p. 25). This piece, like so many of Xu Bing's subsequent works, is a challenge to the cognitive powers of its viewers, but when viewed with eyes accustomed to art filled with political messages, its incomprehensibility, and thus its silence on this score, was profound.

Soon after, the China National Art Gallery agreed to rent space for the New Wave show *Chinese Modern Art Exhibition* during the coming Chinese New Year holiday. Under the overall direction of Li Xianting and Gao Minglu, and with a large and talented, if inexperienced, curatorial team, the exhibition, eventually known in English as *China/Avant-Garde*, finally opened in February of 1989. If some of the exhibition organizers and artists, as I have argued elsewhere, were so accustomed to the official patterns of party art patronage that they sought to simply replace the old official art with the New Wave, many of the young artists who participated were there for the sake of art, whether modern or postmodern, and, perhaps equally important, to have a good time.

The work in *China/Avant-Garde* was no longer explicitly thematic, and some was overtly Dadaist, but the evident concerns spanned religion, philosophy, sex, urban life, and individual freedom. Only Wang Guangyi's *Grid Mao* (similar to p. 28) adopted imagery that had direct political resonances, and it was reportedly defended in the approval process as exemplifying rationalism, a quality that China needed, by Shao Dazhen, editor of the party art journal *Art*. Perhaps most newsworthy was an unapproved performance by Xiao Lu, a graduate of the Zhejiang Academy of Fine Arts and daughter of the Soviet-trained director of that institution, who fired a handgun, reportedly obtained by her well-connected boyfriend, into her installation in the crowded gallery. As this was observed by a plainclothes security officer, the exhibition was quickly closed, the pair arrested, and frantic negotiations between the curators and police ensued. The exhibition reopened, with promises from the curators of good behavior, only to be shut down again by a bomb threat. Nevertheless, the exhibition, in all its chaos, was a major event in the lives of many of its artists and in the Chinese art world, bringing new possibilities for China's art out into the open. Moreover, as occurred with the conservative *National Exhibition* of 1984, *China/Avant-Garde* curators actively sought private collectors for the exhibited work. Some works therefore remain in the collections of individuals who recognized the historic significance of the unfolding events. If all that followed had been different, it might have been recognized not only as the first major exhibition of contemporary installation art in China, but also as China's entrance, however modest, into the contemporary art market.

Two months after the exhibition, the sudden death of disgraced party leader Hu Yaobang led to student and labor demonstrations all over China. Ended only by the bloody events of June 4, 1989, in Tiananmen Square, this exhilarating period of artistic liberalism and experimentation was pushed underground for a period of almost three years. Many artists fled overseas; others turned inward. Time to digest new information and to study enabled them to transform post-Maoism into postmodernism. When the New Wave reemerged, it was no longer so innocent.

Xu Bing once suggested to me that a factor in the extraordinary creativity of artists of his generation was what they didn't know. For them, graduating from art school in the late 1970s and early 1980s, the world outside China's creaky gates was one of absolutely limitless possibility, one they could only imagine, and one that they conceived as a realm of total creative independence. Unfettered by undue comprehension of the workings of the Western art world, and still largely oblivious to the concept of art as a commodity, they threw themselves body and soul into expressing themselves in a way they thought suitable to this ideal world of pure freedom. This talented generation decisively overturned the canons of socialist realism and brought contemporary Chinese art out of its Maoist isolation. They did not plummet into the void left when Mao's Cultural Revolution was discredited in 1979, but instead, with remarkable creative capacity, proceeded to fill it.

Partial ignorance of the West, of course, was accompanied by profound personal and collective knowledge of China's contemporary reality and, on an individual basis, certain narratives of its past. Most obviously, these artists all knew the common ideological and visual culture so effectively and thoroughly promulgated in the People's Republic of China after 1949. At the same time, never completely gone were those remnants of literati culture, Confucian social duty, antiquarian enthusiasms, religious instincts, and cosmopolitan style that had been gradually banned as the Communist government consolidated its control over the citizenry, but traces of which still existed during the childhood years of China's baby boom generation.

The art of the post-Mao era has thus been built, in part, upon what the artists know: their common socialist Chinese culture and their personal experiences and background. One might situate Xu Bing's work quasi-biographically in the

scholarly environment of Peking University, where he grew up, or Zhang Peili's in the medical context of his parents' work unit in Hangzhou (p. 27). One might see in Gu Wenda's work its regional roots, iconoclastically appropriating the epigraphic taste of Shanghai's pre–World War II cultural elite (p. 62), or in Huang Yongping's a similar postmodern reference to the deep-rooted, or in Maoist terms "superstitious," Fujianese religious subculture of his home province (p. 25). Suppressed for thirty years, and in many cases their cultural and artistic traditions completely severed, seemingly random cultural fragments nonetheless reemerged from the memories or interests of China's post-Mao generation, and began to repopulate the "great blank" left by the Cultural Revolution.

The very idea of the "great blank" (*da kongbai* 大空白) that constituted the ten years between 1966 and 1976 suggests a great deal of nothingness. Such could not be further from the truth—the visual world of the Cultural Revolution suffered not from emptiness but from excess. The bombastic images of slogans, wall paintings, posters, and calligraphic condemnations, exquisitely decorated blackboards, mimeographs, basketball courts, gymnasia, dining halls, meeting rooms, and billboards, accompanied by the constant din of loudspeakers, provided a kind of sensory overload. The real challenge for artists in the 1980s was to selectively free themselves from this noise, and from the cultural burdens Mao had placed on their shoulders, a legacy that defined not only art-making but life itself, as they had always lived it.

1 For a good translation and analysis, see Bonnie S. McDougall, *Mao Zedong's "Talks at the Yan'an Conference on Literature and Art": A Translation of the 1943 Text with Commentary* (Ann Arbor: Center for Chinese Studies, University of Michigan, 1980).

2 Ralph Croizier, "The Avant-Garde and the Democracy Movement: Reflections on Late Communism in the USSR and China," *Europe-Asia Studies*, 51, no. 3 (May 1999), 484.

3 Chen Duxiu, "Meishu geming," in *Xin Qingnian*, 6, no. 1 (Jan. 15, 1918), as excerpted in Lang Shaojun and Shui Tianzhong, *Ershi shiji zhongguo meishu wenxuan* (Shanghai: Shanghai shuhua chubanshe, 1999), vol. 1, 29–30, and Kang Youwei, "Wanmu caotang canghuamu," 1917, as excerpted in Lang and Shui, 21–5.

4 Arnold Chang, *Painting in the People's Republic of China: The Politics of Style* (Boulder, Colo.: Westview Press, 1980).

5 For one description of the program, see Julia F. Andrews, *Painters and Politics in the People's Republic of China*, 1949–1979 (Berkeley and Los Angeles: University of California Press, 1994), 148–61. For a 2002 satirical reinterpretation, see Cai Guoqiang's Maksimov Collection (*http://www.caiguoqiang.com/shell.php?sid=2*).

6 Bonnie S. McDougall, "Writers and Performers, Their Works, and Their Audiences in the First Three Decades," in *Popular Chinese Literature and Performing Arts in the People's Republic of China, 1949–1979* (Berkeley: University of California Press, 1984), 292.

7 The closest competitor for this claim might be the court art of the Song dynasty, particularly of the twelfth and thirteenth centuries, which followed imperial taste quite closely.

8 For a compelling account of her engagement with posters as a schoolchild, see Xiaomei Chen, "Growing Up with Posters in the Maoist Era," in Harriet Evans and Stephanie Donald, ed., *Picturing Power in the People's Republic of China* (Lanham, Md.: Rowman and Littlefield, 1999), 101–22.

9 For one such account, see Xiaomei Chen, "Growing Up with Posters in the Maoist Era."

10 For a recent retrospective, which includes an invitation to the Stars "Outdoor Exhibition," scheduled for September 27 to October 3, 1979, see Zhu Zhu, ed., *Yuandian (Origin Point)* (Hong Kong: Shijie yishu chubanshe [Visual World Arts Publisher], 2007), 217.

11 Gao Yan (Li Xianting), "Bushi duihua, shi tanxin—zhi xingxing meizhan," *Meishu* [*Art*], 1980, no. 12, 33–6.

12 Interview with Zheng Shengtian, who served as chair of the Oil Painting Department and head of the Foreign Affairs Office, Vancouver, August 13, 2006.

13 For one summary of this conference, see Gao Minglu, et al., *Zhongguo dangdai meishushi*, 1985–86 (Shanghai: Shanghai renmin chubanshe, 1991), 61–7. More complete publication of conference papers appeared in *Meishushi lun*, 1985, no. 4.

14 Many surrealist paintings appeared in the mid- and late 1980s. One well-known example is Zhang Qun and Meng Luding's *New Era: Adam and Eve's Awakening*, in which expulsion from the Garden of Eden is reinterpreted (or misinterpreted) as a celebration of newfound knowledge and self-awareness. It was exhibited at the *International Youth Art Exhibition* in May 1985, organized by the China Youth League.

15 *Zhongguo meishu bao [China Art News]*, no. 22.

16 For an excellent retrospective of many of his works, see *House of Oracles: A Huang Yong Ping Retrospective* (Minneapolis: Walker Art Center, 2005). For work from his early years abroad, see Julia Andrews, "Art in Its Environment: Huang Yong Ping's Installations," *Fragmented Memory: The Chinese Avant-garde in Exile* (Columbus, Ohio: Wexner Center for the Arts, 1993), 24–7.

17 Mimeographed abstracts—"Zhuhaishi huayuan chengli" (Establishment of the Zhuhai Municipal Painting Institute), "Zhuhaishi huayuan shoujie yuanzhan" (The Inaugural Exhibition of the Zhuhai Municipal Painting Institute), and "'85 qingnian meishu sichao daxing huandengzhan jianbao" (Brief Report on the Large Slide Show on the '85 Youth Art Tide)—were prepared by the conference reporters, Wang Xiaojian, Chen Weiwei, and Chen Weihe.

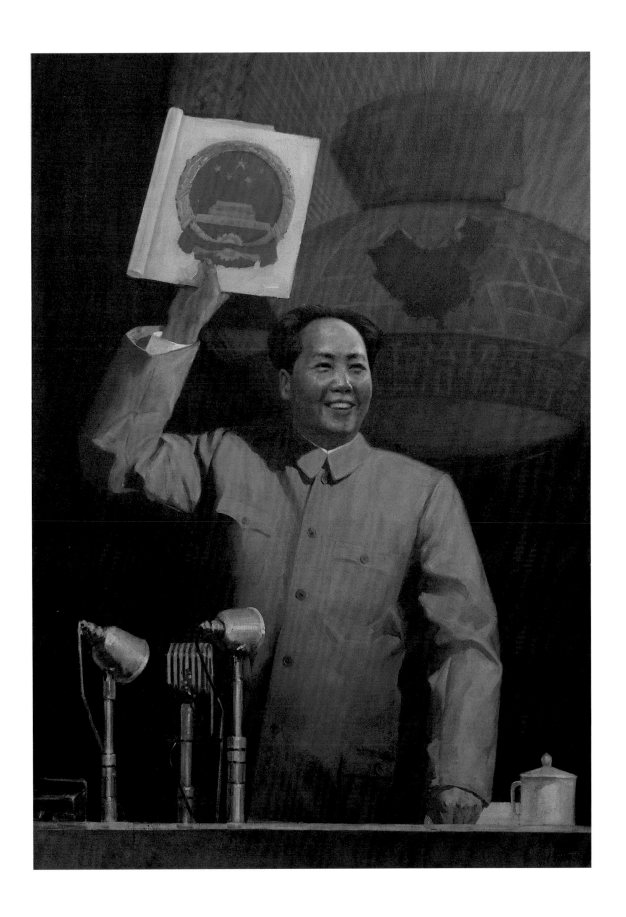

GUANG TINGBO

My Name Is P.L.A. (Lei Feng)

1973

SUN GUOQI

Chairman Mao with the
New National Emblem

1973

QIU SHIHUA
Untitled
1992

QIU SHIHUA
Untitled
1992

CHEN GUANGWU
Untitled
1996

CHEN GUANGWU
Untitled
1996

ZHAN WANG

Artificial Rock No. 31

2001

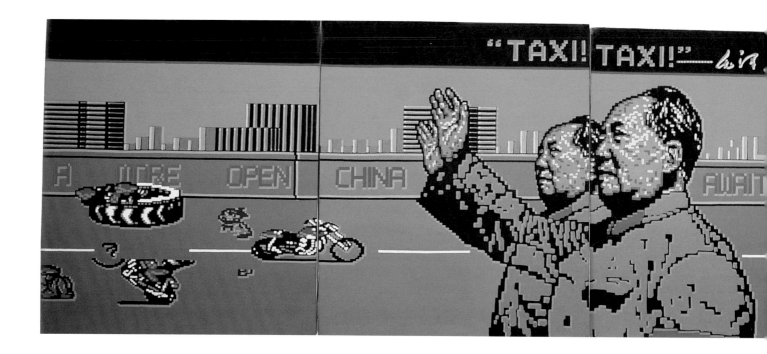

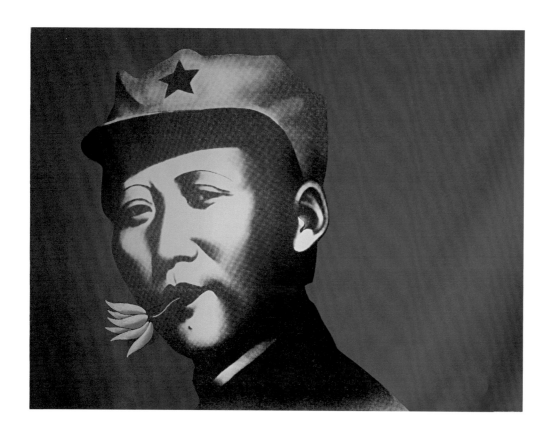

FENG MENGBO
Taxi! Taxi!
1994

LI SHAN
Rouge—Flower
1995

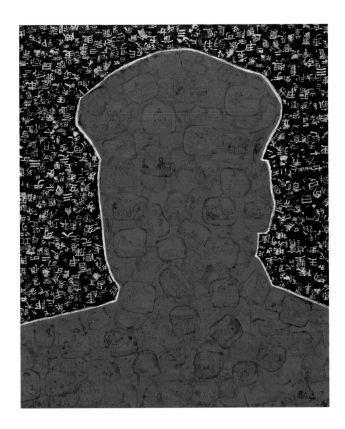

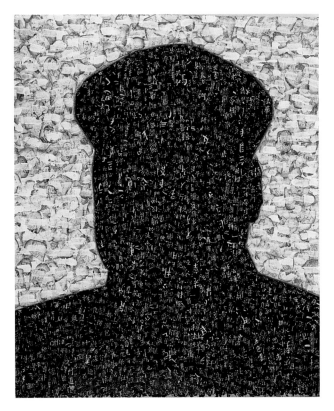

XUE SONG

Shape (Red Mao)

1996

XUE SONG

Shape (Black Mao)

1996

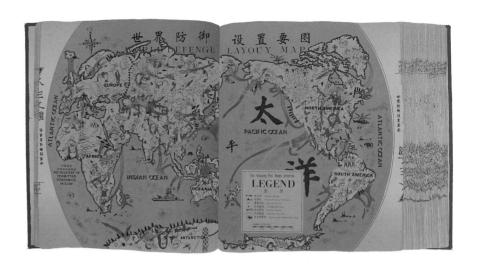

HONG HAO
Scripture
1995

HONG HAO
Beijing No. 5
1998

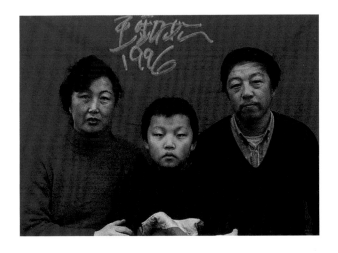 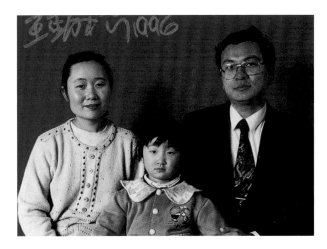

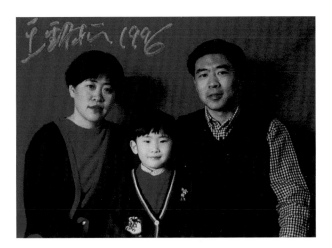 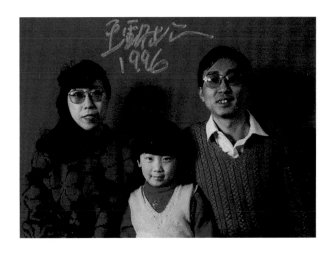

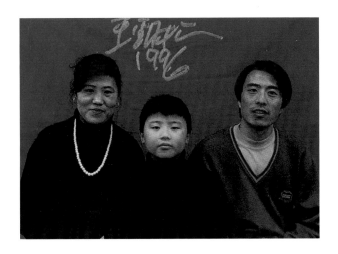 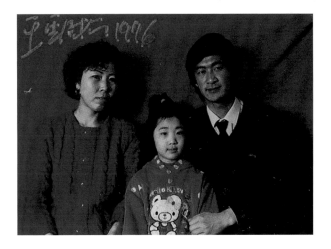

WANG JINSONG

Standard Family (detail)

1996

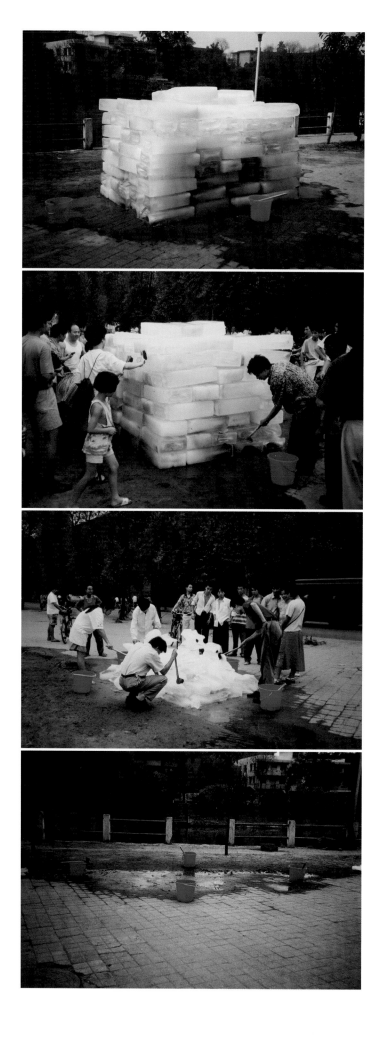

YIN XIUZHEN

Washing River

1995

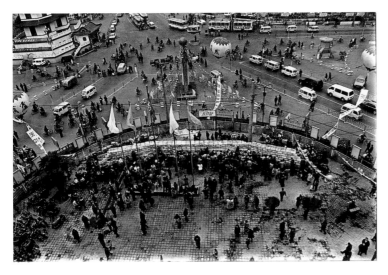

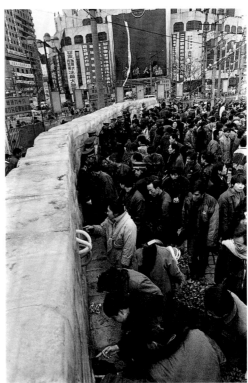

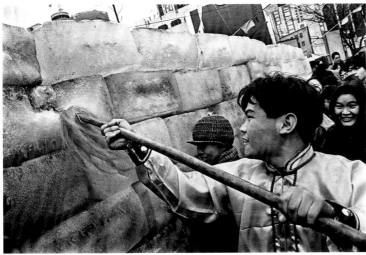

WANG JIN

Ice Wall

1996–2004

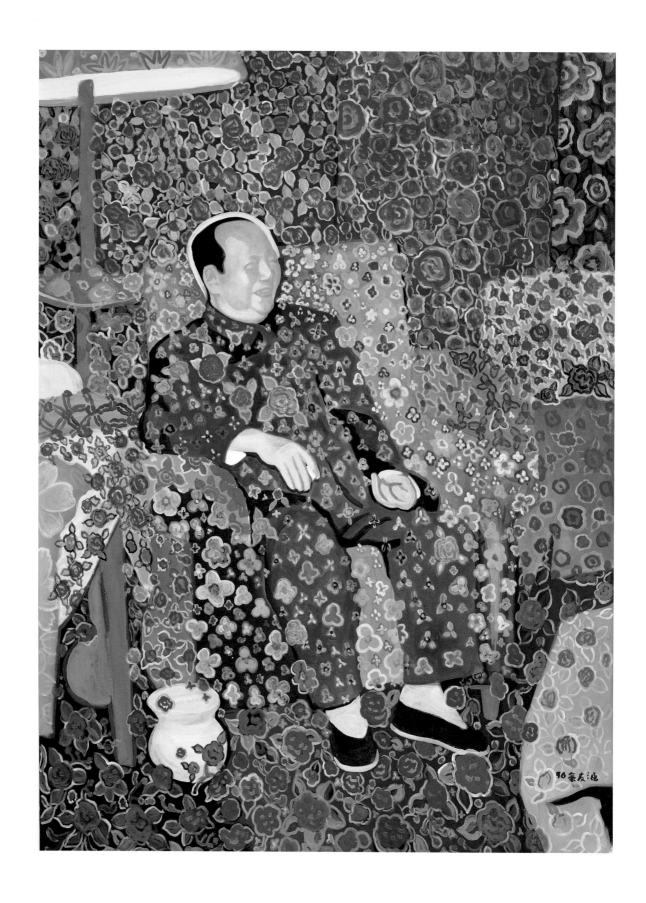

YU YOUHAN
Untitled (Chairman Mao)
1996

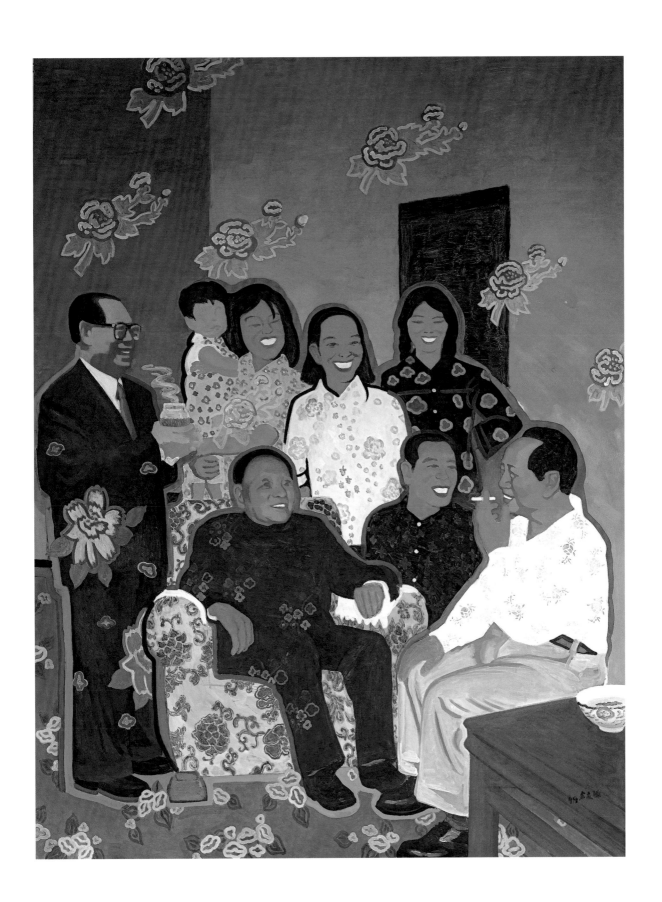

YU YOUHAN

**Chairman Mao in Discussion with
the Peasants of Shaoshan**

1999

49

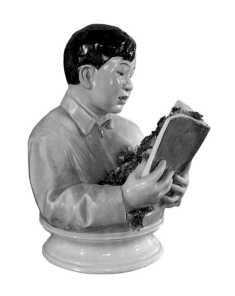

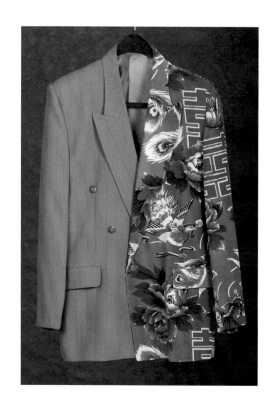

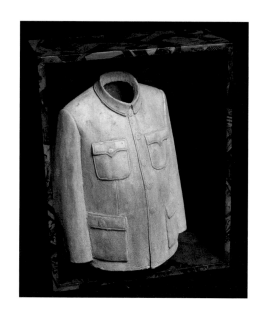

XU YIHUI
Boy Reading Mao Book
1998–99

WANG QIANG
Untitled (Chinese textile blazer)
1998

QI ZHILONG
Untitled
1999

SUI JIANGUO
Legacy Mantle (Mao Jacket)
1998

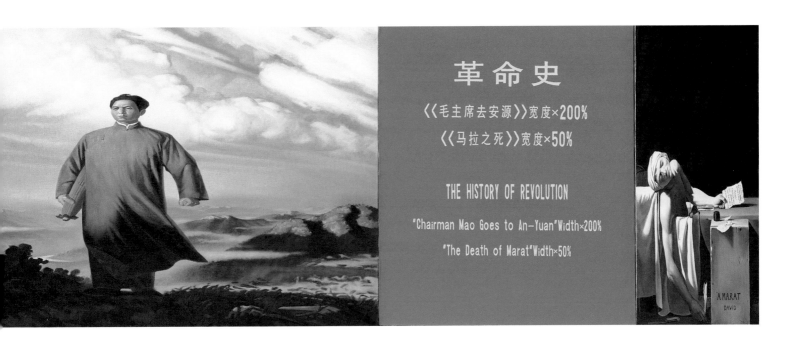

 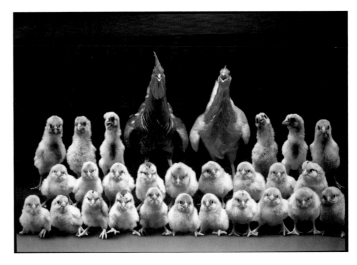

WANG XINGWEI

History of Revolution

1997

YANG ZHENZHONG

Lucky Family (3)

1999

YANG ZHENZHONG

Lucky Family (1)

1999

ZENG FANZHI
Untitled
1997

YUE MINJUN
Everybody Connects to Everybody
1997

Opposite page
YUE MINJUN
La Liberté guidant le peuple
1995

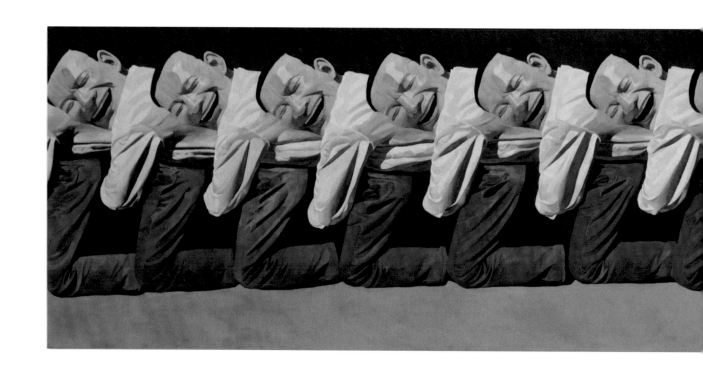

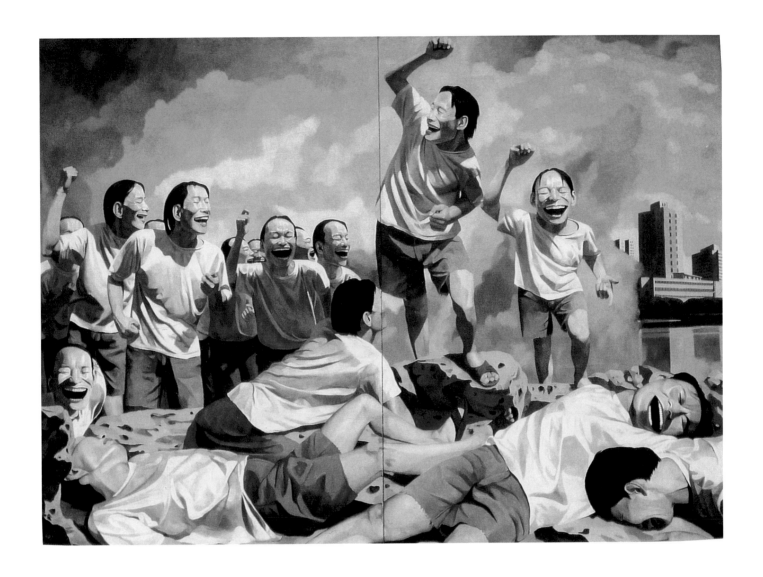

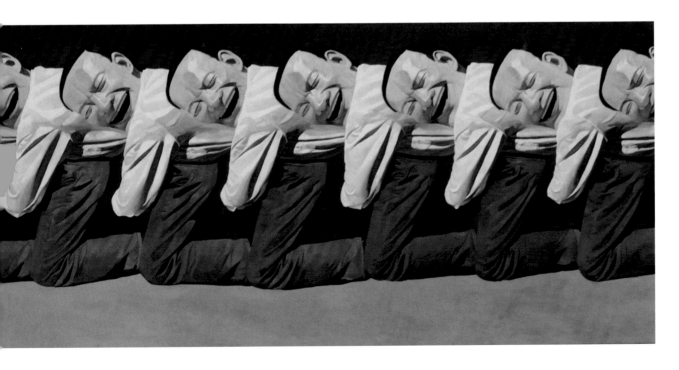

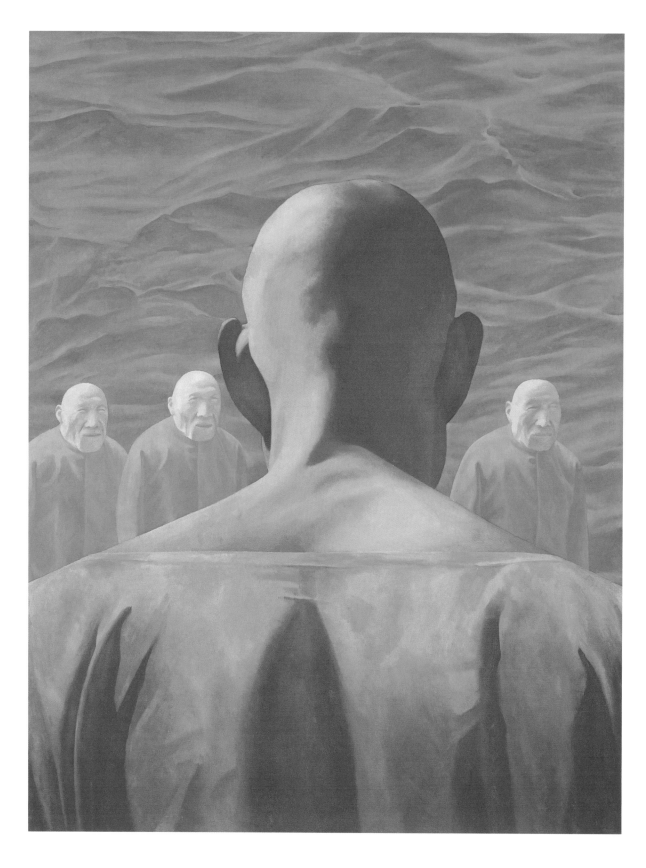

FANG LIJUN
Untitled
1995

FANG LIJUN
Untitled
1998

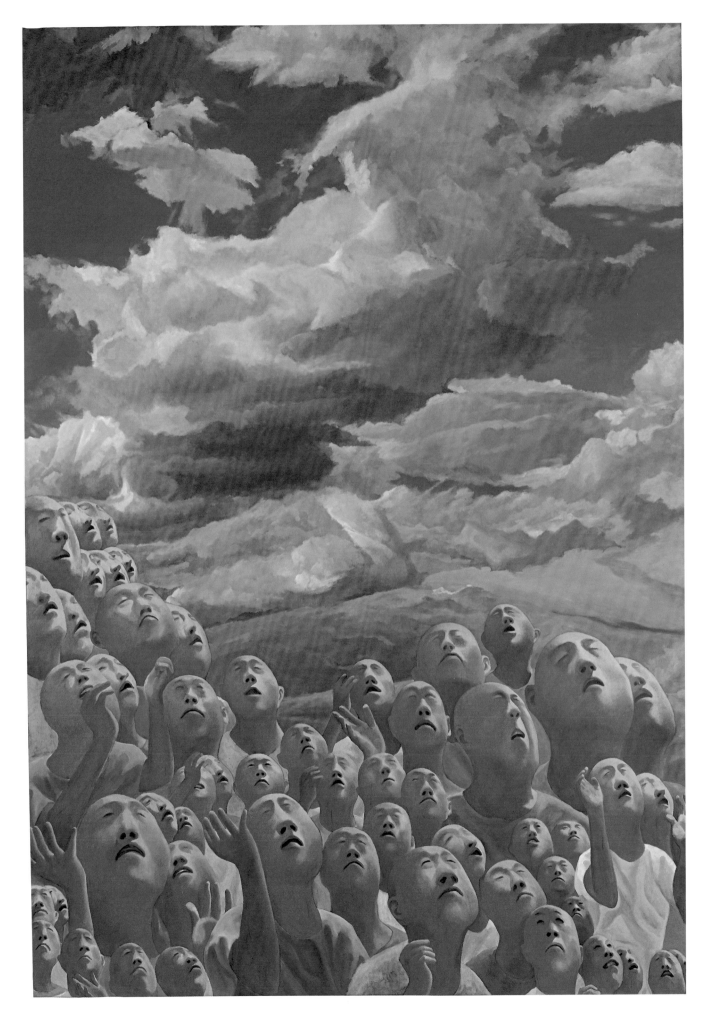

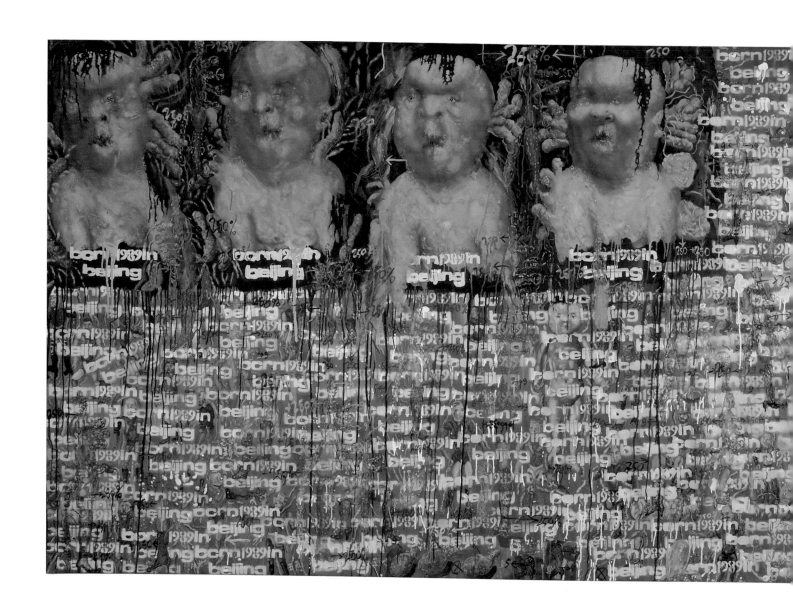

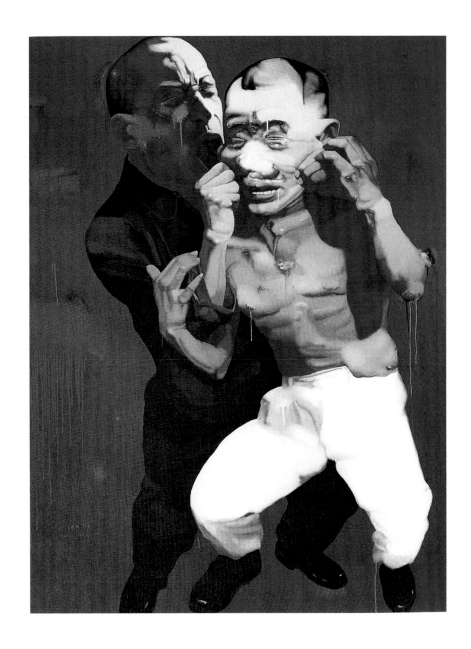

LIU WEI

Born 1989 in Beijing

1995/96

YANG SHAOBIN

Untitled

1996

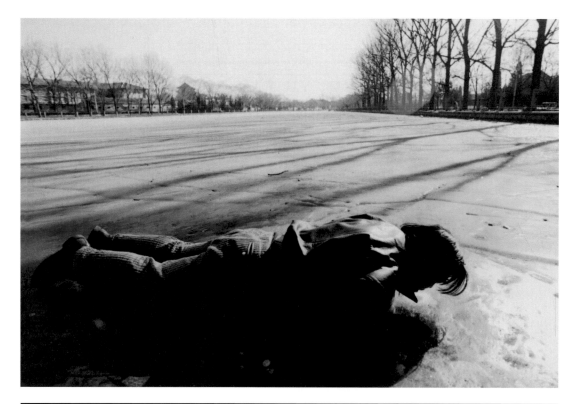

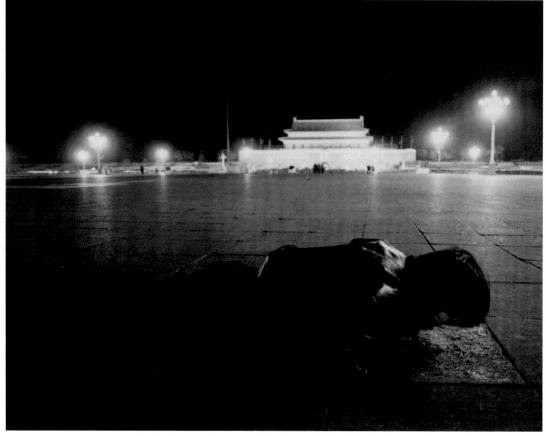

SONG DONG
Breathing
1996

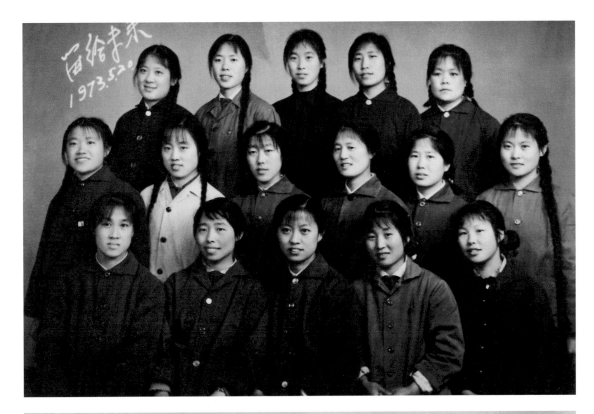

HAI BO

They Recorded for the Future

1999

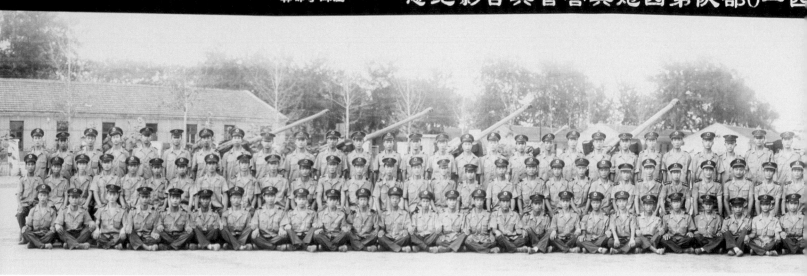

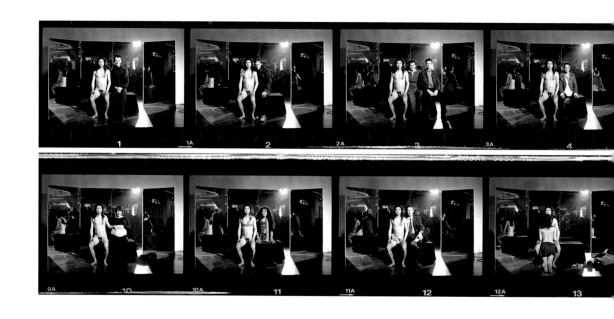

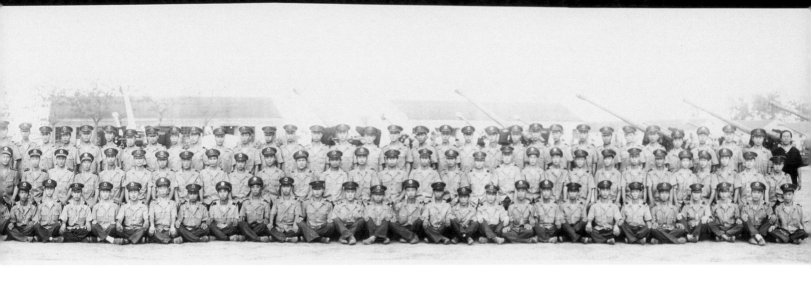

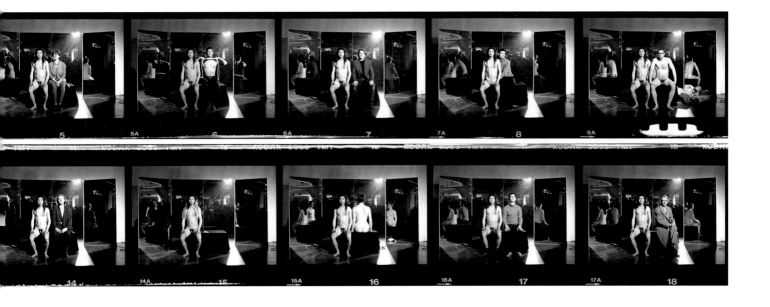

ZHUANG HUI
June 23, 1997, Hebei Province, Handan City, PLA
Regiment 5141, Fourth Artillery Squadron—
Group Photograph of Officers and Soldiers
1997

MA LIUMING
Fen-Maliuming in Geneva 1999 Switzerland
(detail)
1999

GU WENDA

Myths of Lost Dynasties

1999

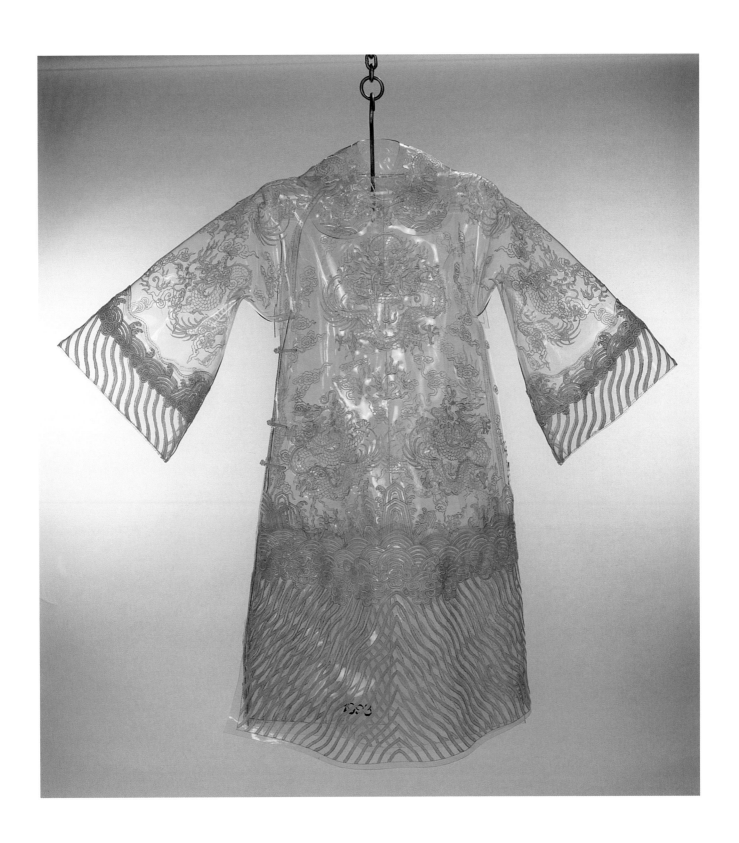

WANG JIN

The Dream of China

1997

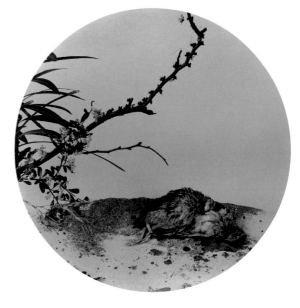

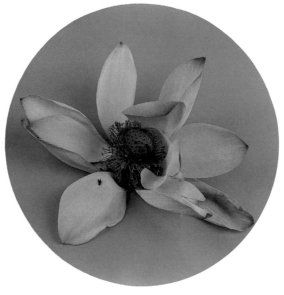

CHEN LINGYANG

Hanging Scroll

1999

HONG LEI

Lotus

1998

HONG LEI

**After Song Dynasty
Painting by Li Zhongan**

1998

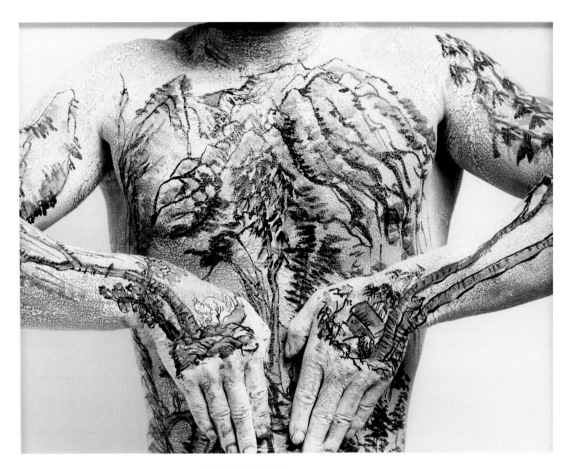

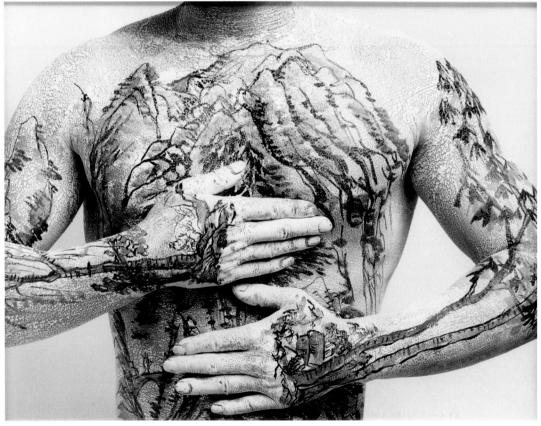

HUANG YAN

Chinese Landscape: Tattoo No. 6

1999

HUANG YAN

Chinese Landscape: Tattoo No. 2

1999

4

1

2

5

6

3

7

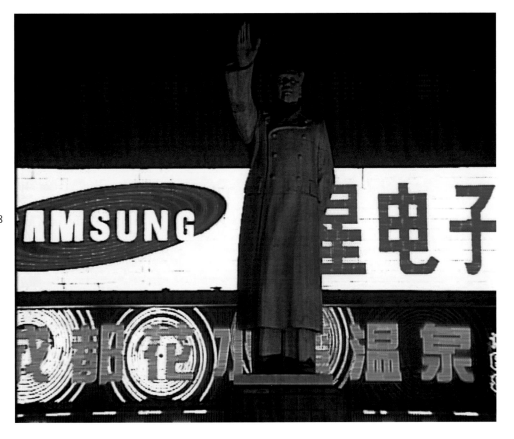

8

9

ZHANG XIAOGANG
Red Child
2005

No U-Turn: Chinese Art After 1989 Kuiyi Shen

The year 1989, a turning point in the political life of China, also had a profound impact on the country's art and artists. After the June 4 massacre at Tiananmen Square, under strong political pressure, the Chinese art world entered a very quiet period. The New Wave that began in the mid-1980s culminated with the February 1989 *China/Avant-Garde* exhibition; after June 4, most artists avoided or rejected participation in official art exhibitions. And although these artists continued to produce art, they had no chance to display their work publicly or to openly organize collective activities, for all such things were harshly attacked as bourgeois liberalism. Between 1989 and 1992, the entire society was under such enormous political pressure that art went underground—and, in its isolated setting, found certain kinds of freedom. Ironically, due to widespread noncooperation with the government's attempt to conduct a cultural crackdown, artists operated in a realm of social isolation that might be characterized as "low-pressure." They could not exhibit, but they continued to work for themselves and for the approval of trusted friends. During this low-pressure period, however, art continued to expand along the lines of the late 1980s New Wave, so that the 1990s brought photography, video, performance, and installation art into common use, breaking the boundaries between media that were still reflected in the official exhibitions.

Artists in China worked quietly and inconspicuously until 1993, when Deng Xiaoping ended China's post–June 4 isolation from the rest of the world and relaunched, with increased vigor, his economic reforms. The Chinese economy entered a period of extremely rapid development that began to dramatically change the entire society. Although the ruling authorities did not undertake any overt political reforms, in the art and cultural worlds an unspoken policy of political relaxation—or,

perhaps, a period of no policy at all—provided an environment in which certain freedoms appeared. At the same time, economic decentralization liberated artists from their previous dependence on state-run work units for income, studio space, housing, and even art supplies, and thus gave them new kinds of personal and creative freedom. Increasing exchange between China and the outside world similarly gave Chinese artists new opportunities to engage with the international art world and even the opportunity to travel abroad. If most of the art of this era continued the trends initiated in the mid-1980s, it took them in some different directions.

In the 1980s, when artists intentionally rejected political themes in art, they turned to "art for art's sake" ideals, absorbing the styles and forms of Western modernism quite directly as a means to overthrow socialist realism. That task was accomplished in both political and artistic terms by the events of 1989. The mid-1990s saw a wave of contemporary Chinese art that moved beyond the more spiritual and abstract forms of modernism to adopt the down-to-earth imagery and iconoclastic concepts of postmodernism. As Chinese artists transformed postmodernism for their own expressive purposes, the rapidity and unpredictability of the societal changes after 1993 provided new subjects and problems for them to represent. Thus, one might say that during the 1980s Chinese art expanded formally, increasing its styles and its media, and adopting different ways of conveying its ideas, but in the 1990s, it began to expand conceptually and thematically, as well. This may be attributed in part to looser political control of artists in the 1990s as compared to the 1980s, but also to increasing maturity in their understanding of the international art world, new knowledge of the global economy, and shifting ideas of their own relationship to Chinese society. In response to these

factors, a highly dynamic art world reemerged in China after 1993 that was markedly different from that of the 1980s.

Perhaps the sharpest difference was the shift away from the non-thematic work of the 1980s toward more personal expressions of concern over a wide array of issues in society. At the same time, artists have challenged or simply ignored the customary division of Chinese art into categories based on media, such as ink painting, oil painting, sculpture, and woodblock prints. Medium is no longer an issue. Three artists whose work focuses on the body are typical. Ma Liuming's performances are normally presented as photographic or video works. In them, he personally acts out a dual-gendered character he calls Fen-Ma Liuming, who has a female head and nude male body (p. 60). Chen Lingyang explores the female body, particularly her own (p. 64), while He Yunchang engages in seemingly masochistic challenges to his own powers of physical endurance (p. 100).

Beyond this explicitly personal approach, beginning in the early 1990s Chinese artists began to show far more interest in everyday life than they had in the previous decade. Postmodernism is a Western concept, but it began to develop in China during a period of rapid change, when social and economic phenomena that had not been seen for thirty or forty years suddenly reappeared, and artists felt impelled to make new art that dealt with their own mental and physical reality. We see this in the work of Liu Xiaodong (p. 75), Yue Minjun (pp. 2, 52, 53, 74), and Yang Shaobin (p. 57), who express themselves through critical analysis of the human body. Zhang Peili's series of paintings of disposable gloves, as well, is both very personal and very physical—one must insert one's hands into the plastic sheaths in order to ensure safety and sanitation—but also very dehumanizing, as by this technological advance, the most important manual sensation, touch, is lost (p. 27).

On the other hand, the newly commodified society and rapidly developing economy provided a rich variety of themes for social critique. In the background of all such works, tradition served as a reference, or even as a target in the case of explicitly antitraditional work. For artists of this generation, Chinese tradition meant not just premodern art but also art of the more recent Mao period, including Mao's images, forms from the Cultural Revolution, iconic socialist realist images, and even the Maoist transformation of Chinese folk art. In general, as works

by Yu Youhan (pp. 5, 48, 49), Li Shan (p. 42), and Wang Guangyi (pp. 26, 28, 84) attest, the strongest references in this new postmodern art were to Chinese traditions and society.

One cannot deny that the sudden opening of China, this era of rapid economic growth, and a new consumer society brought a better standard of living to many Chinese. However, as Chinese society abandoned its previous economic egalitarianism, it quickly began dividing socially and economically in new ways. The gap between rich and poor, urban and rural emerged with dramatic speed and troubling effects. A rather bold critique of consumerism is acutely registered in the Political Pop works of Wang Guangyi that began to appear in the early 1990s, as the artist returned to Cultural Revolution art for both his format and his icons. Using images of Red Guards destroying the old society to express his reaction to economic developments was a powerfully direct response to the new materialism (p. 84). The Luo Brothers, in the mid-1990s, similarly brought imported consumer goods into the frame of folk art. They returned to the forms of auspicious *yuefenpai*-style calendar pictures of the socialist realist 1950s and 1960s to critique the growing importance of "name brands" in Chinese consumer life (p. 120). They went a step further to bring an extreme form of mundanity, or intentional "vulgarity" (*yansu*), into their work by merging folk art and socialist realism of the past with commercialization of the present. They used different models, but for an ironic purpose similar to that of Wang Guangyi's work.

Wang Jin's *Ice Wall* (p. 47), an installation in which the artist froze many desirable consumer goods into blocks of ice that were then placed on a public square in semi-tropical Guangzhou, similarly comments on the desire and greed that people in today's China have for consumer objects. Such concerns on the part of the artists have become ever more acute as society continues to develop. Weng Fen's *On the Wall* series (p. 94) goes beyond consumer goods to worry about the dehumanizing nature of China's massive new real estate ventures.

Beginning in the 1990s, depictions of *xiaorenwu* (little characters), unidealized and now sometimes grotesque images of ordinary people, became increasingly important in fiction, film, TV dramas, and art. In the new economy, many people have found the prospect of improving, or even maintaining, their old lives to be hopeless. This helplessness in the face of change

has led to works that contrast strongly with both the idealism of the 1970s and the beauty of the 1980s. The videos of Wang Jianwei focus on the results of new economic development and the gap between rich and poor (p. 67). Painters such as Liu Xiaodong, Yue Minjun, Zhang Xiaogang (p. 68), and Fang Lijun (pp. 54, 55) treat the subject of the ordinary person in a variety of ways, but often with a rather bitter tone.

Zhou Tiehai brilliantly comments on several of these themes simultaneously. Acutely aware of the essential role of the media in this new order, he makes fake magazine covers featuring his own image (p. 73). In his early series of magazine covers he converts himself, a nobody, into a popular press icon by injecting his image into every imaginable print context. Zhou Tiehai and his work represent an extreme challenge to a new social order based on a highly commercialized economy; whereas others point out the hopelessness of the ordinary person in the changing social hierarchy, he makes his nobody into a somebody, and thus points out how artificial, ephemeral, and empty social position might be.

Zhou Tiehai's new work continues to satirize the elite through his parodies of classical scroll paintings, which are faithfully airbrushed onto canvases by his assistants (p. 76). The possible targets of these innocuous images are numerous—the commodification of China's classical heritage; those who appreciate and study classical paintings; those who write about parallels between Western modernism and Chinese literati or Chan painting; those who collect classical painting as investments; and those art historians, curators, and dealers who facilitate the entire enterprise. But despite, or perhaps at the source of, the irony, his well-selected reproductions possess a certain beauty.

The period after 1993 was the first era of comparative creative freedom since the Cultural Revolution, and it included the possibility of reexamining the Cultural Revolution and Mao's period in art. Icons became the preferred vehicle for a number of such artists. Yu Youhan incorporated the aesthetics of folk fabrics and peasant paintings into his Mao icons; Li Shan and Xue Song (p. 42) adopted their icons from historical photos of Mao. Sui Jianguo, in his Mao suit series (p. 50), deconstructed the icon, but left the power of its empty shell remarkably intact. Shi Xinning's *Duchamp Retrospective Exhibition in China* (this page) similarly played with the iconic image of Mao by

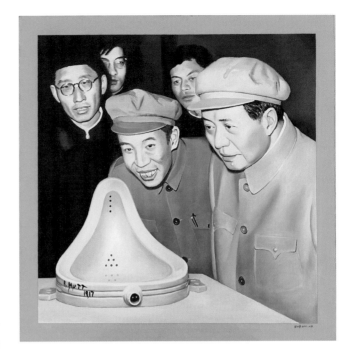

fabricating an event that never occurred, Mao's imaginary viewing of Duchamp's *Fountain* (1917), presented the way a new socialist realist creation might have appeared in a newspaper of the 1950s.

The site of Tiananmen served an iconic role, as well. Feng Mengbo, in his *Taxi* series of the late 1990s, merged the political icon of the Maoist generation, Mao waving to the masses, and that of the consumerist generation, Nintendo, by developing a video game image in which Mao's upraised arm is used to hail a taxi at Tiananmen Square (p. 42). Song Dong's *Breathing* (p. 58), in which he exhaled on the wintry pavement in front of Tiananmen Square until he had marked it with ice, and Yin Zhaoyang's *Tiananmen Square* (p. 91) both challenge the aura of this symbolic political space.

Just as massive reconstruction, dislocation, and social restructuring are taking place in China, artists have moved beyond political icons to approach the larger topic of cultural memory from multiple points of view, in photos, films, and installations. Hai Bo's reflections upon youth and age delineate the seismic shifts of the nation, along with the profound changes in the lives of individuals (p. 59). Yin Xiuzhen, taking women's work as her theme, commemorates intimate aspects of domesticity under Mao, such as the expectation in the

SHI XINNING
Duchamp Retrospective Exhibition in China
2000–01

socialist economy that women would clothe themselves and their family members by knitting in every spare moment (pp. 46, 66). Qi Zhilong refers to the ideal of the supposedly genderless Maoist of the Cultural Revolution by posing a beautiful young girl in a Mao suit (p. 50). Zhang Xiaogang's *Bloodlines* creates an imaginary world of genderless monochromatic families, posed as all such social units in his youth would have commemorated themselves.

Zhang Peili comments on the common culture of China's state-run media in his 1992 video piece *Water: Standard Pronunciation Ci Hi (Sea of Words)* (p. 66). For this production, he hired Xing Zhibin, the well-known newscaster whom the public saw as the face and mouth of the authorities: people knew her as the person who read the latest party proclamations on the evening news. Zhang Peili employed this voice of the party, posed and dressed just as she appeared on CCTV, to read a prolonged entry, "Water," from the authoritative Chinese dictionary, *Cihai*. Particularly in the wake of June 4, this piece initially raised ominous expectations in the minds of its Chinese viewers, and when it filled their ears with empty words, instead convulsed them with laughter. A brilliant piece, it is as clear on some scores as it is ambiguous on others.

Even in this rapidly modernizing society, some premodern traditions periodically revisit the creative realms of cutting-edge artists. They appear to Zhan Wang as the symbol of the literati garden, the Taihu rock, which he re-creates in highly polished stainless steel (p. 41). Ai Weiwei adopts a deconstructive approach to his objects—literally cutting apart Ming dynasty furniture to reassemble it as nonfunctional design, or over-painting the decor on Neolithic painted urns, believed by some to be the ultimate source of the Chinese written language, and thus literally resignifying these archaeological icons with contemporary meaning (frontispiece, p. 15). Chen Guangwu deploys the abstract beauty of traditional calligraphy for his own modern ends (p. 40). Finally, the endlessly innovative Xu Bing returns periodically to attack the Chinese script from a new direction (p. 25).

Artists of the past decade in China have thus turned to a range of social and political issues as subjects, from the individual to the social, economic, political, and cultural. Painful examinations of the raw human body, images of China's unfortunate "small characters," manipulation of the icons of

socialist realism and of Maoism, explorations of common cultural memories, ironic analyses of consumer culture, troubling studies of urban reconstruction, and occasional engagements with the burden of Chinese tradition emerge among the many themes of Chinese art today. The formal and technical experiments of the 1980s, which brought installation art, video art, and performance art, among other new expressive means, into their vocabulary led to a reconfiguration of the mental world of artists and curators. In the 1990s, categorization by medium, such as oil, ink, or woodcut, was challenged, and by the new millennium, official exhibitions, such as the Shanghai Biennial, began to reflect this change. New media were officially accepted as part of the 2000 Shanghai Biennial, and from this time forward, exhibitions have incorporated both new media and new concepts. The conceptual developments of the 1990s broke through into a more mature understanding of postmodernism on the part of both the artists and the new generation of curators and arts administrators in China. At the same time, the extraordinary changes in China's physical, social, and economic environment provide constant subject matter for artistic commentary and representation.

The logo for the 1989 *China/Avant-Garde* exhibition was a "No U-Turn" sign. The idealism of this image was finally realized, many years later, as a result of the persistent hard work of artists during the past two decades, beginning with those in the underground between 1989 and 1992. Propaganda and formalism have both been left behind, and postmodern approaches are part of the mainstream. Social commentary has emerged as a constant element of China's contemporary art. As the then-young artists and curators of the 1980s had hoped, China has joined the international art world. There is today, as they so boldly proclaimed in 1989, no turning back.

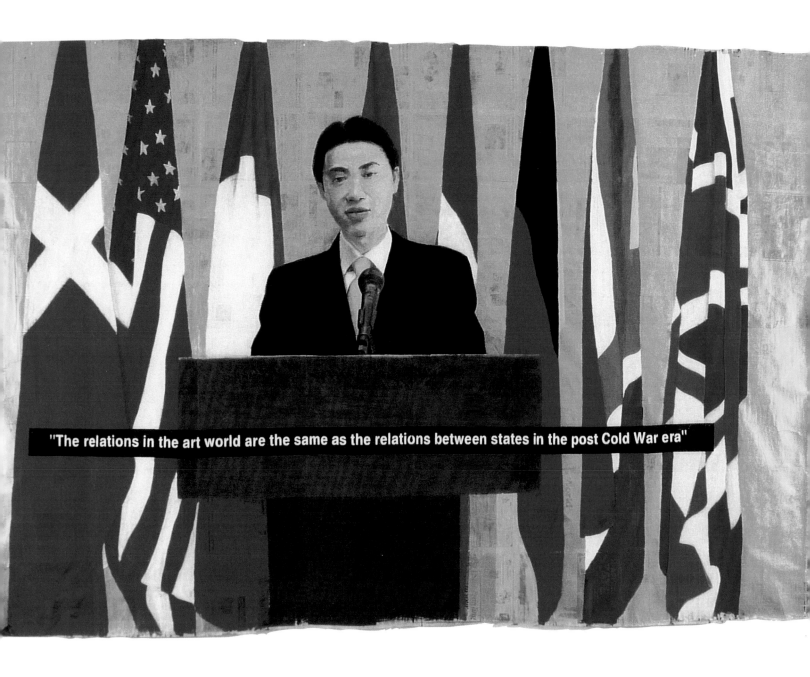

ZHOU TIEHAI
Press Conference III
1996

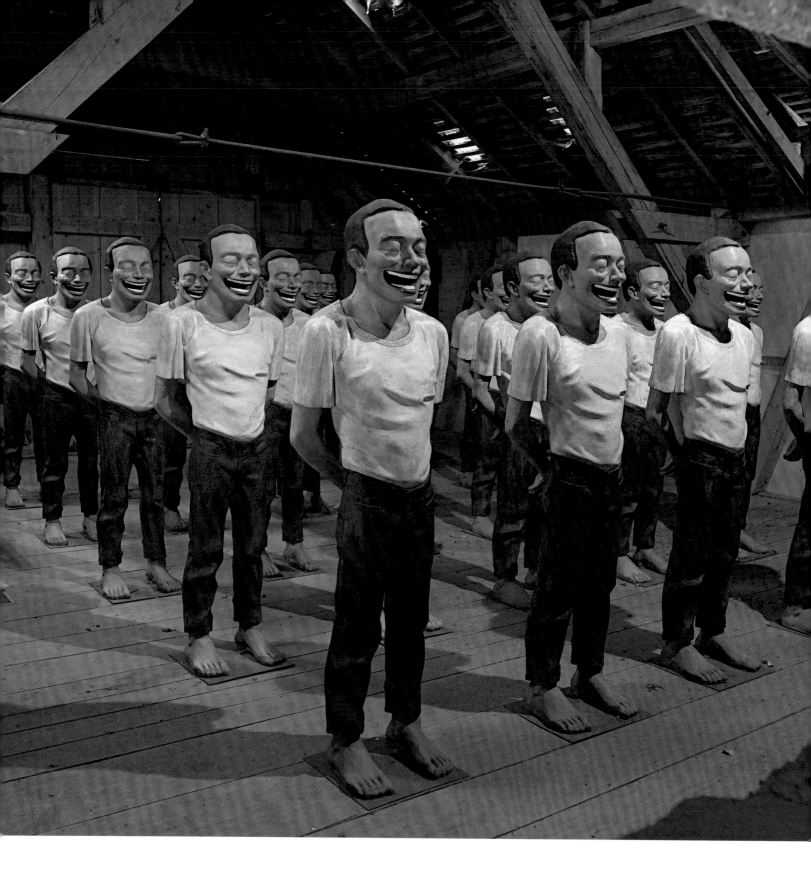

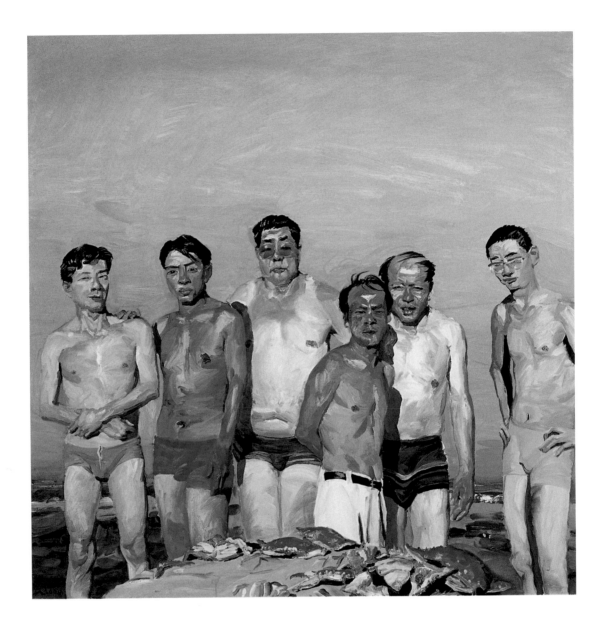

YUE MINJUN

2000 A.D.

2000

LIU XIAODONG

Eating

2000

Opposite page
SHI XINNING
Dialogue
2001

ZHOU TIEHAI
Li Bai (Tonic series)
2002

ZHOU TIEHAI
Placebo series
2001

YAN LEI
The Curators
2000

LU HAO

Recording (2005) Chang'an Street

(detail)

2005

LU QING
Untitled
2000

MIAO XIAOCHUN

The Great Wall 2000 Years Ago

2001

MIAO XIAOCHUN

Restaurant

2001

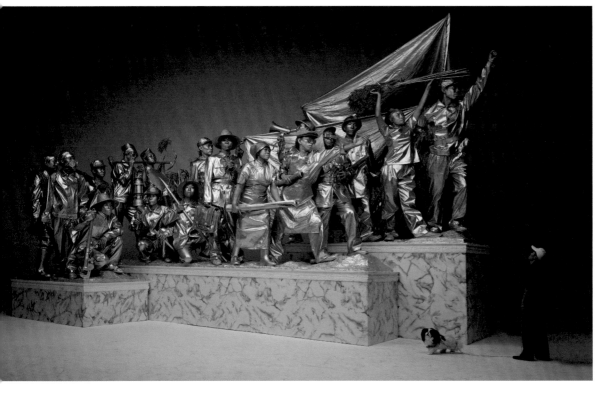

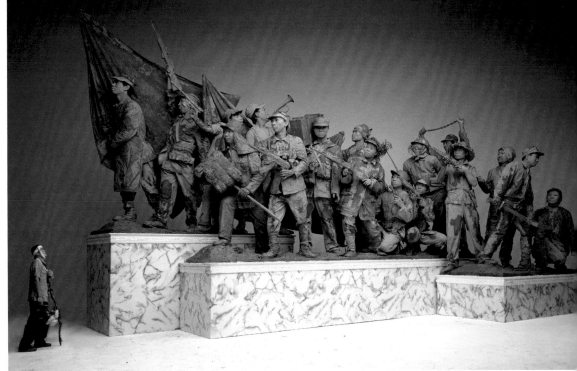

WANG QINGSONG

Past, Present, Future

2001

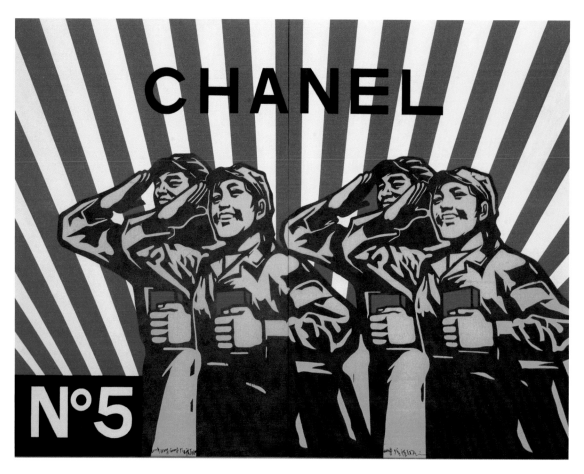

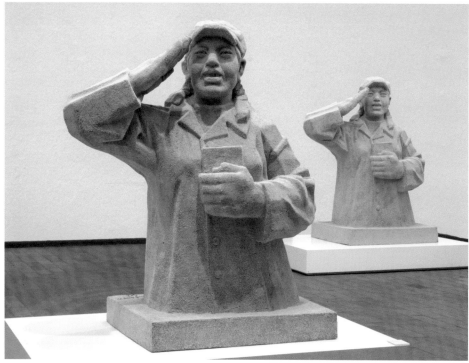

WANG GUANGYI
Chanel No. 5
2001

WANG GUANGYI
Materialist (Two Women)
1999

 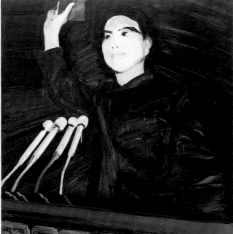 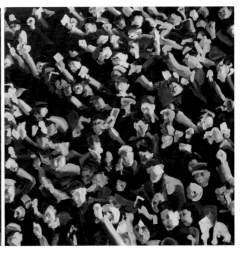

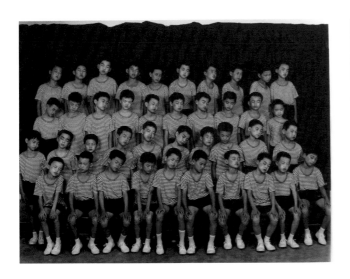

LI SONGSONG

Wave (Jiang Qing, Wife of Chairman Mao Zedong)

2002

WANG NINGDE

Some Day No. 9

Some Day No. 11

2002

CHANG XUGONG

Dollar—Eurocurrency Series (1 $)

2003

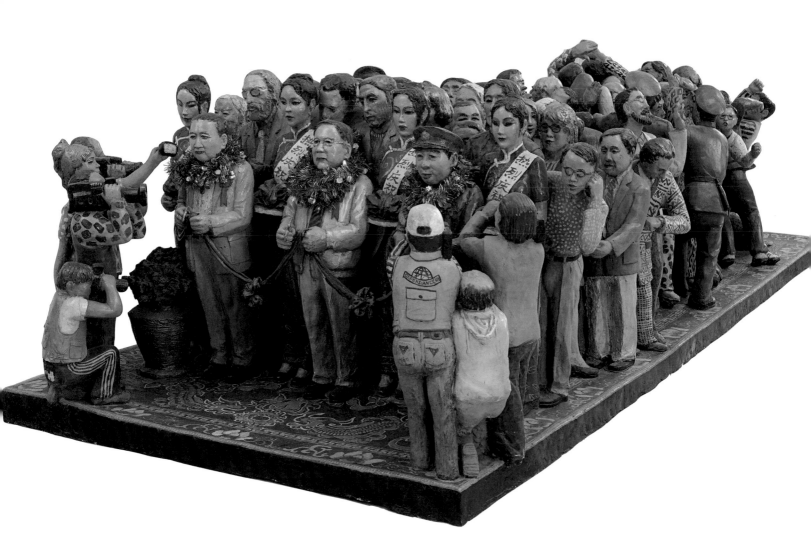

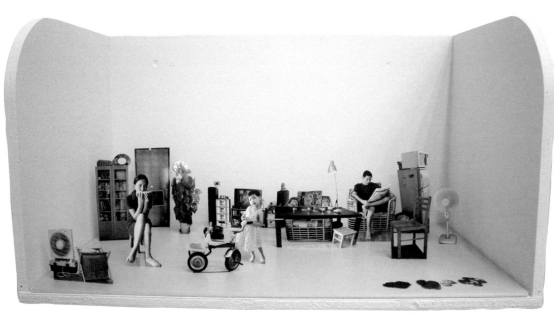

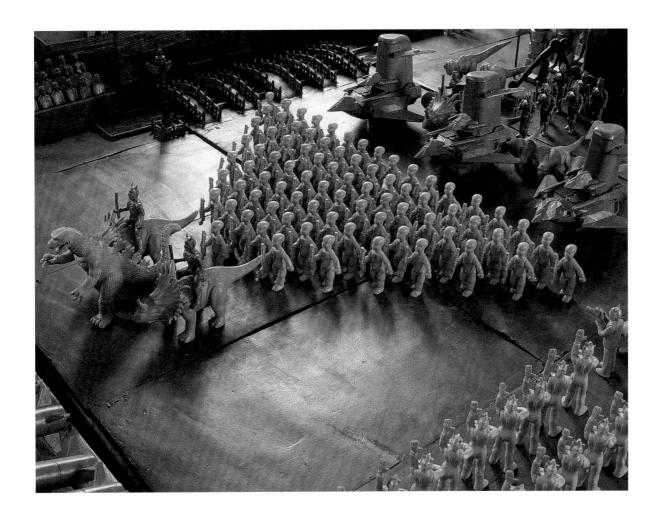

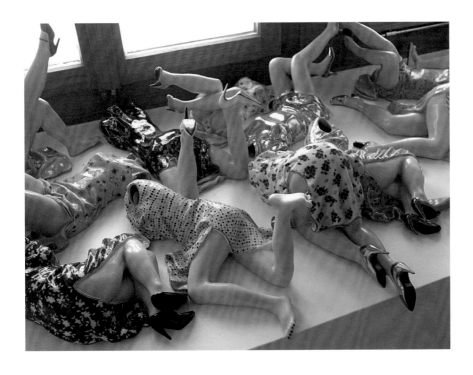

ZHOU XIAOHU
Parade (detail)
2003

LIU JIANHUA
Obsessive Memories
(detail)
2003

Opposite page
LI ZHANYANG
Opening Ceremony
2002

CHEN SHAOXIONG
Homescape (detail)
2002

SHI GUORUI
Shanghai, China, 15–16 October 2004
2004

AI WEIWEI
Map of China
2003

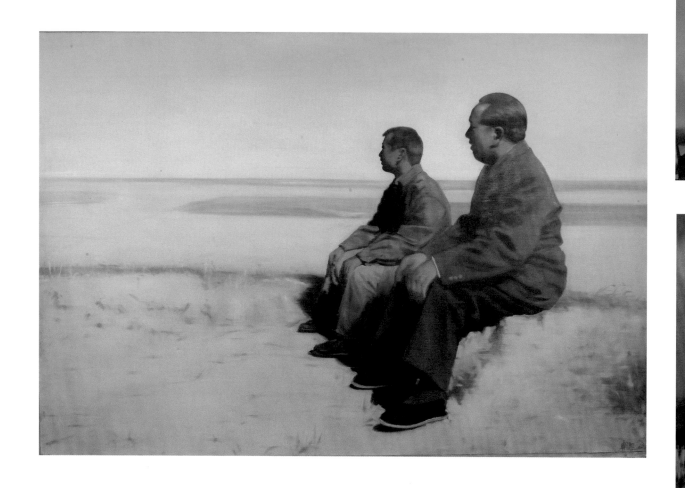

LIU YE
Gun
2001–02

YIN ZHAOYANG
Yin Zhaoyang and Mao
2003

YIN ZHAOYANG
Tiananmen Square
2003

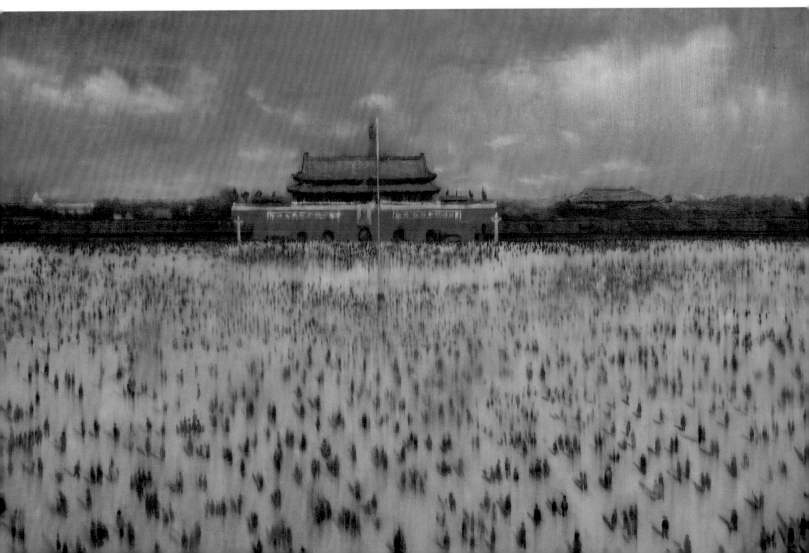

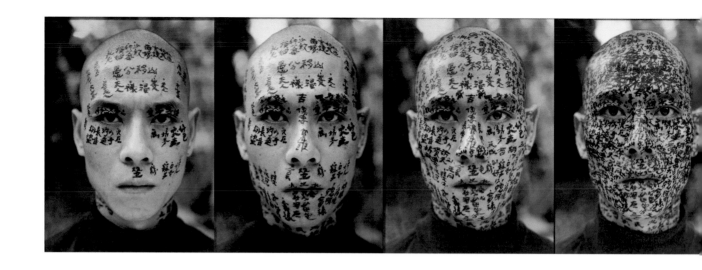

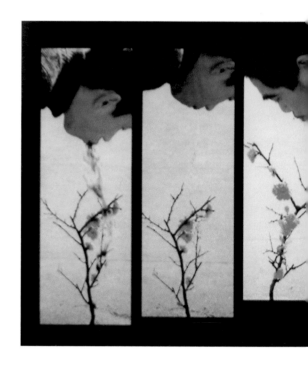

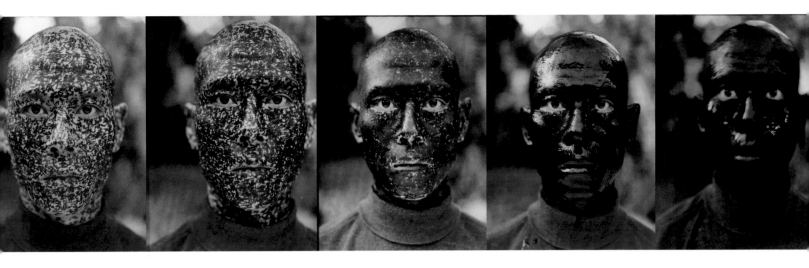

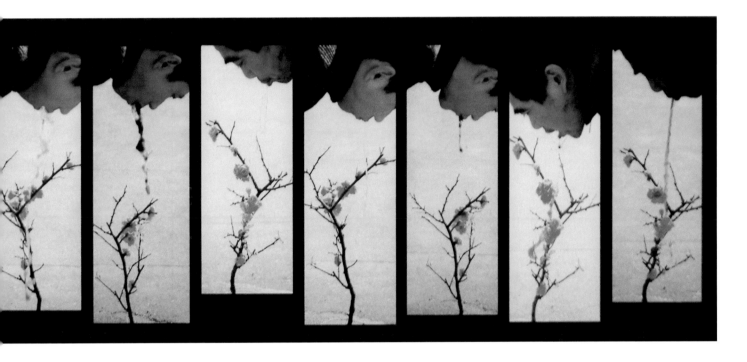

ZHANG HUAN
Family Tree
2000

CHEN XIAOYUN
Untitled
2003

DU JIE
2003.1.15–2003.3.3
2003.4.14–2003.5.9
2003.5.10–2003.5.28
2003

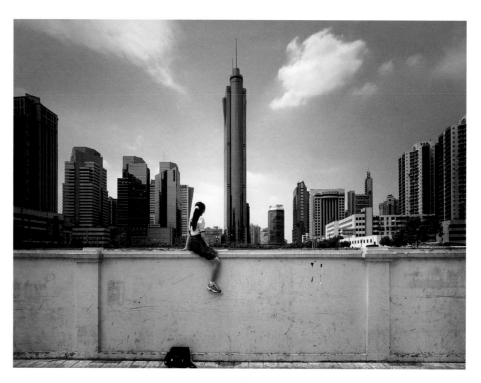

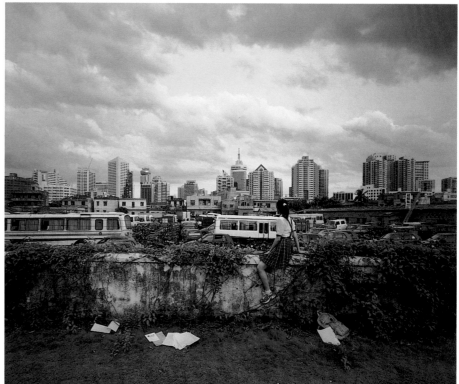

WENG FEN
On the Wall—Guangzhou (II)
2002

WENG FEN
On the Wall—Haikou (6)
2002

SHAO YINONG and MU CHEN
**The Assembly Hall—Xingguo
Wenchang Temple**
2002

SHAO YINONG and MU CHEN
The Assembly Hall—Changting
2002

LI SONGSONG

Wonderful Life

2004

LIU ZHENG

The Four Beauties

2004

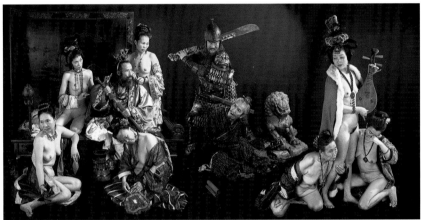

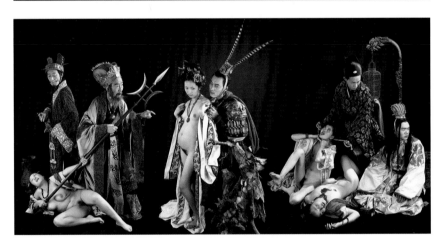

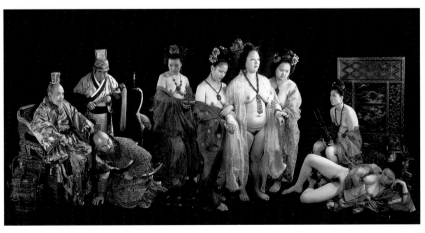

隨事遷感慨係之矣向之所
欣俛仰之間以為陳迹猶不
能不以之興懷況脩短隨化終
期於盡古人云死生亦大矣
不痛哉每攬昔人興感之由
若合一契未嘗不臨文嗟悼不
能喻之於懷固知一死生為虛
誕齊彭殤為妄作後之視今
亦由今之視昔悲夫故列
敘時人錄其所述雖世殊事
異所以興懷其致一也後之攬
者亦將有感於斯文

趣舍萬殊靜躁不同當其欣

非所遇蹔得於己快然自足不

或因寄所託放浪形骸之外雖

一世或取諸懷抱悟言一室之内

娛信可樂也夫人之相與俯仰

所以遊目騁懷足以極視聽之

觀宇宙之大俯察品類之盛

是日也天朗氣清惠風和暢仰

盛一觴一詠亦足以暢敘幽情

列坐其次雖無絲竹管弦之

湍暎帶左右引以為流觴曲水

有崇山峻領茂林脩竹又有清流激

也羣賢畢至少長咸集此地

于會稽山陰之蘭亭脩禊事

永和九年歲在癸丑暮春之初會

CHEN ZAIYAN

Three Famous Xingshu Documents

2004

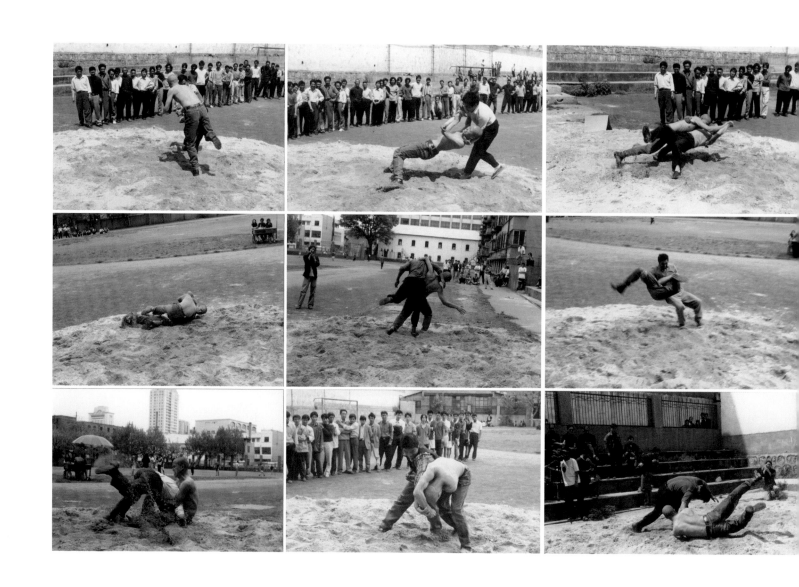

HE YUNCHANG
Untitled (2001 performance)
2004

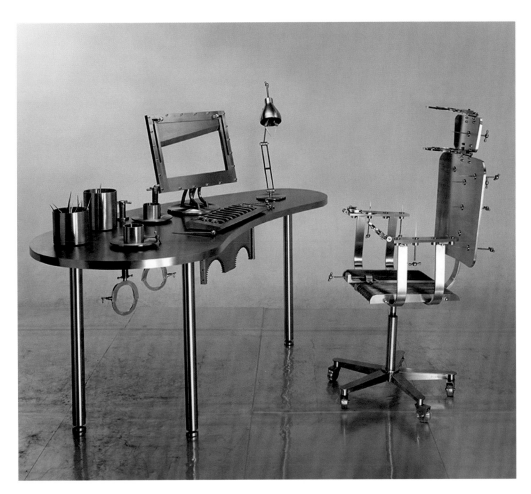

SHI JINSONG

Office Equipment—Prototype No. 1

2004

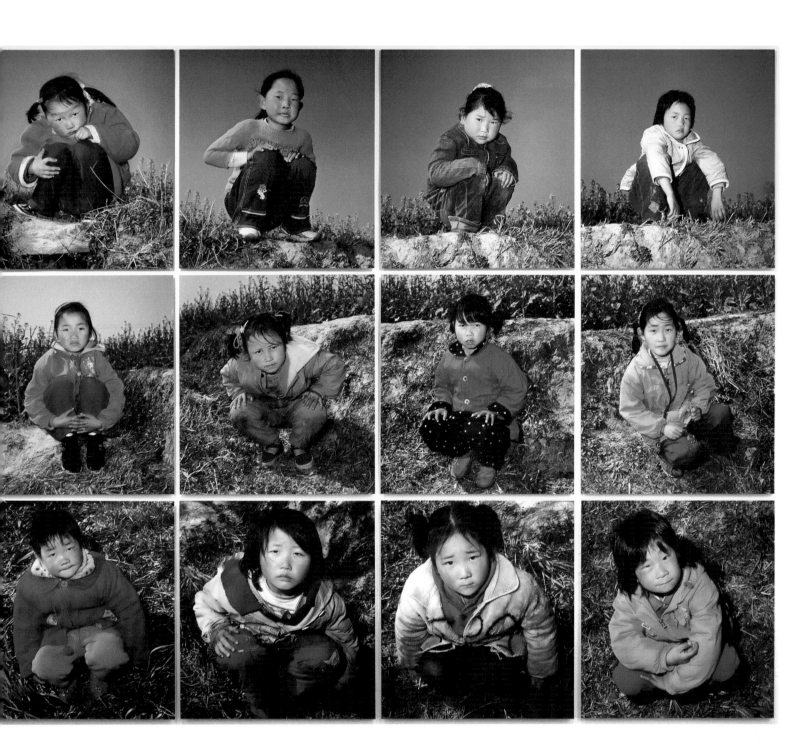

ZHANG O
Horizons
2005

TIAN WEI
Mind
2006

XIE NANXING

Untitled (No. 1)

2006

ZHENG GUOGU
Computer Is Controlled by Pig's Brain
2006

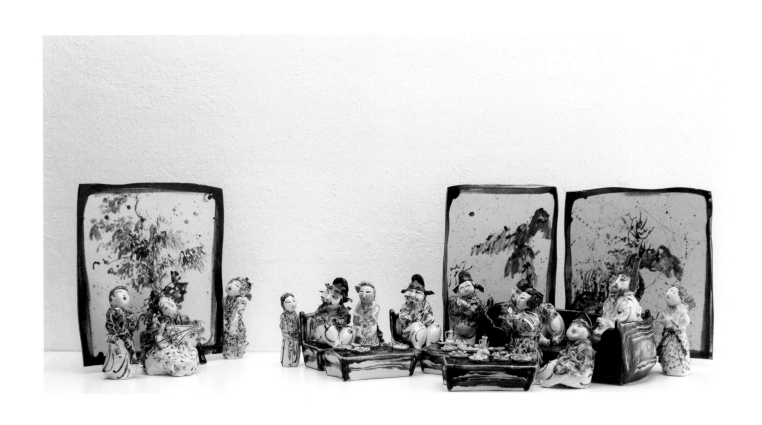

GENG XUE
Han Xizai Dinner, No. 2 (detail)
2007

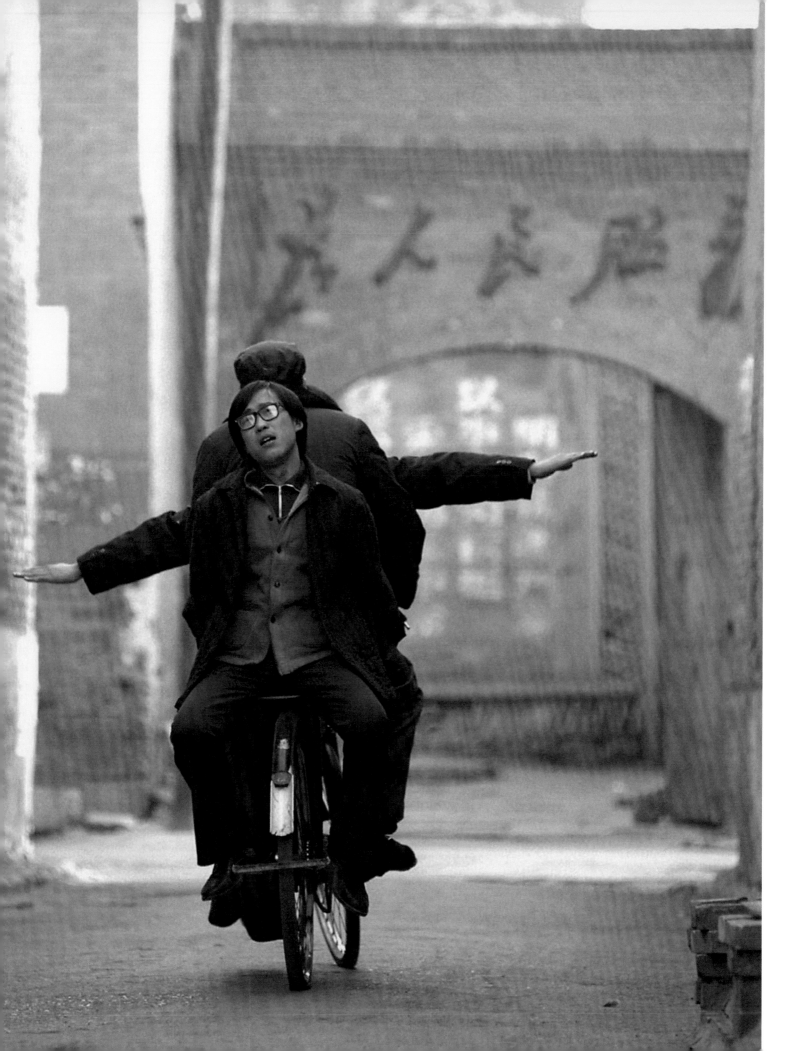

Unknown Pleasures: The Films of Jia Zhangke James Quandt

"Guess the dreams always end/They don't rise up, just descend."—Joy Division

Chinese meteorologists assured fretful government officials that no rain would dampen the opening festivities for the 2008 Olympics in Beijing, so thoroughly can they control the weather with cloud seeding and other atmospheric manipulation. Jia Zhangke, who has become the bard of the new China over the last decade with his densely poetic films about the dislocation and anxiety caused by Deng Xiaoping's market "reforms," would immediately recognize the bitter, proliferating metaphor in that claim: manufactured utopia and enforced optimism—it's always fair weather!—ecological hubris as accomplice to autocracy, and the arrogating power of spectacle in a country intent upon erecting a pristine facsimile of late civilization over the drowned villages, polluted skies, and broken hopes of its populace. In the fireworks that erupt over derelict Datong in *Unknown Pleasures* (*Ren Xiaoyao*, 2002) immediately after television carries news of Beijing's successful Olympic bid, or in the hermetic artifice of a gleaming global village, edited only to its high touristic points for a theme park, in *The World* (*Shijie*, 2004), Jia portrays the China made by post-Mao officials and functionaries: a vast "show," as he called it in a 2004 interview,[1] to divert attention from the immense social costs of the abrupt shift from collectivism to a rapacious form of laissez-faire.

Born in 1970 in Fenyang, a rural town in Shanxi Province where his parents had been dispatched during the Cultural Revolution, Jia was concerned early on with those "left behind" as statist capitalism replaced Maoist communism (from dialectical to brute materialism, as it were). Jia's first films, set in dusty peasant outposts in Shanxi, feature a series of luckless provincials who are oblivious to or uncomprehending of the invisible forces that buffet their lives—a pathetic pickpocket in *Xiao Wu* (1997), a young theater troupe outdistanced by cultural change in *Platform* (*Zhantai*, 2000), two morose, unemployed teenage boys and their intractable girlfriends in *Unknown Pleasures*. Bewildered or merely benumbed, Jia's characters transform themselves according to rapidly changing styles of pop culture (karaoke bars and the influx of consumer products in *Xiao Wu*; bell-bottoms, perms, and break-dancing in *Platform*; Taiwanese pop and international fashion in *Unknown Pleasures*), constantly revising their identities while trapped in helpless stasis. Transport is a central trope in Jia's cinema, his characters always on the move, by train, bicycle, and subway (*Xiao Shan Going Home* [*Xiaoshan huijia*], 1995), bus or jitney (*Xiao Wu*; *Platform*), motorbike (*Unknown Pleasures*), lorry or monorail (*The World*), and boat (*Still Life* [*Sanxia haoren*], 2006), but no one gets anywhere: they either end where they started, or are left stranded or stalled. At the close of *Unknown Pleasures*, when Xiao Ji's motorcycle breaks down as he flees the police on the new superhighway linking Datong with Beijing, the road's very promise of escape mocks his futile attempt. When the young workers in *The World* finally do make it to Beijing from the regions, they find themselves immured in a counterfeit environment designed to obliterate history, simulating freedom of experience and movement even as its confined totality—the entire world in a highly redacted, easily transited simulacrum—embodies the opposite.

The title of Jia's student film at the Beijing Film Academy, *Xiao Shan Going Home*, suggests this very tension between seeming movement and actual stasis: the hapless Xiao Shan desperately attempts to go home but never succeeds; his trips

Platform

2000

across Beijing to secure a train ticket or traveling companion are all in vain. Wang Hongwei—who would become a central member of Jia's troupe, along with actor Han Sanming, cinematographer Yu Likwai, and the director's muse, actress Zhao Tao—plays Xiao Shan, a long-haired country boy fired from his job as a kitchen helper. Planning, like millions of Chinese, to return to his village for New Year's, he asks others from his hometown, including a prostitute who tells her folks that she is a housemaid, to join him, but everyone is more concerned with staying in the city to make money, sacred tradition already surrendering to capitalism. Jia's cardinal theme—the depredations of life in post-Maoist China—finds its first expression here, as does the bereft tone that would prevail in his succeeding work, its dispassionate observation, occasionally verging on documentary or reportage, enlivened by self-deprecating comedy (Jia appears in a drunken dormitory sequence spouting his native Shanxi dialect, one of several such directorial cameos in his films). The film's quest-journey structure and subject of urban migration, Jia's experimentation with language and image (intertitles containing newspaper stories or Xiao Shan's vital statistics, for instance), and his copious use of found sound and pop music, from The Carpenters to The Crash Test Dummies, all point the way to his later films: the allusive audioscape of *Unknown Pleasures*, the interpolations of flash animation and text messaging in *The World*, the startling science fiction touches in *Still Life*, and, throughout, the insistent references to popular culture, including *Pulp Fiction*, "Monkey King," Joy Division, and Chow Yun-fat.

Wang Hongwei returns in Jia's first feature, *Xiao Wu* (or, as it is known in English to signal the director's debt to the French director Robert Bresson, *Pickpocket*[2]), as a two-bit pilferer working the backstreets of Fenyang, Jia's hometown. Xiao's trade has been rendered even more ignoble by the economic boom that has turned his childhood friend from petty crook into a "model entrepreneur" who drops his old pal and partner in crime to achieve respectability. In the opening sequence, Xiao tries to make a bus conductor believe he is a policeman, introducing a motif of imposture in Jia's cinema, a metaphor of malleability that extends to the country's cultural and physical essence. In the new China, where all is flux and unfixed, remaking oneself seems easy for some—Xiao Wu's friend handily refashions himself as a "big boss," expunging his criminal past—while the government, always adept at fabrication (as exemplified by the model city of Guangzhou in *Platform*), cynically remakes terrain according to its needs, simulating and subsuming the capitals of the world into a theme park (*The World*) or submerging villages to construct a dam (*Still Life*). Jia treats Xiao Wu, his peasant parents, and the wily karaoke hostess Mei-Mei with profound empathy, the seeming freedom of his script belying a strict tripartite structure that explores how commodification has changed three kinds of relationships—social, sexual, and familial—in this now endlessly transmutable world. Laid bare emotionally, morally, physically by Jia's probing method, which combines Bressonian precision and gritty naturalism, Xiao Wu comes to represent the drift and desertion of a rural class, a subject to which Jia would frequently return.

With their shabby regionalism, documentary-like observation, and emphasis on youth culture, their low-fi formats (video and 16mm, respectively) and underground distribution, *Xiao Shan* and *Xiao Wu* marked a break with the then predominant, internationally celebrated, and state-sponsored Fifth Generation of Chinese directors, which included Chen Kaige and Zhang Yimou. "After four years of watching Chinese films," Jia remarked, "I still hadn't seen a single one that had anything to do with the reality I knew."[3] The lead figure of what quickly and conveniently became known as the Sixth Generation of Chinese filmmakers, hitherto break-dancer and artist Jia found his own financing and made and distributed his films outside officially prescribed channels, in the art and film underground that burgeoned in the 1990s. (Ironically, two of Jia's most damning critiques of the new China, *The World* and *Still Life*, received official sanction, while his previous features were available only on pirated DVDs, the source of a resentful in-joke in *Unknown Pleasures*.) "You have seen too many foreign movies," a cop warns two youths in *Platform*, something Jia's Fifth Generation elders might have said about him. Though he includes Chen Kaige's debut film, *Yellow Earth*, among his inspirations, no doubt for its elliptical narrative and visual abstraction—Chen before his lacquered late style—Jia cites Bresson's *A Man Escaped*, Vittorio De Sica's *Bicycle Thief*, and Hou Hsiao-hsien's *The Boys from Fengkuei*[4] as more formative influences.[5] Judging from the visual style that emerged with *Platform*, Jia's debt to Taiwanese master Hou, in particular, cannot be exaggerated.

To compare Jia with Hou Hsiao-hsien runs the risk of detracting from the younger director's originality, but the similarities of their respective approaches are often striking, especially the combination of poetry and analysis, tenderness and detachment, embodied in a visual style that emphasizes the long, observational take. In Hou, history inheres in the everyday, and the aim of his remote camera, which moves laterally or parks itself at a distance to observe, is, paradoxically, empathy and intimacy. Similarly, Jia's watchful style—which suspends time and forces attention to social detail in *Xiao Wu*, imposes tableaux and frieze-like compositions on the restless itinerants of *Platform*, and conversely roves and floats in the weightless DV mobility of *Unknown Pleasures*—is employed with almost ethnographic objectivity but achieves greater emotional effect than any heavy editing or close-up. "If I were to break up a scene which lasts for six or seven minutes into several cuts," Jia has said, "then you lose that sense of deadlock. The deadlock that exists between humans and time, the camera and its subject."[6] To the impatient, Jia's "deadlock" translates as aloofness or aesthetic impasse, but his withholding pays off in poignancy.

If Jia shares with Hou, the director of such epics as *The Puppetmaster* and *City of Sadness*,[7] an interest in the way history impinges upon the personal, he sticks mostly to what he knows from direct observation, as is apparent in *Platform*. At once sprawling and intimate, the film captures the convulsive social, economic, and political changes in China during the crucial period between 1979 and 1989 by focusing on the

Unknown Pleasures
2002

The World
2004

Useless
2007

(mis)fortunes of a group of young musicians in a provincial theater troupe. The transformation of the country, from "pure" communism to the most acquisitive and corrupt kind of capitalism, is subtly reflected in their lives, as they fall victim to forces of which they are largely unaware, and their values and hinterland dreams begin to change or fade, just as their music turns from rousing Mao propaganda to Cantopop spectacle. In the film's devastating culmination, their All Star Rock and Break Dance Electronic Band performs by the side of a highway, literally and metaphorically sidelined by the setting, by time and history, as in the background boats ferry Panasonics up the river. Precisely detailed in setting and atmosphere—the landscape of the Yellow River is evoked in all its ochre severity—*Platform* is shot with masterful reticence. Employing proscenia to frame his players, maintaining mid-distance from characters, and often using long takes, Jia manages to be both reserved and passionately observant. Enthralling in its formal authority and emotional power, *Platform* was, alas, grievously abridged from its original three-hour version for international distribution, a sign perhaps that Jia was still worried audiences would not respond to his aesthetic of "deadlock."

The transitional short *In Public* (*Gonggong Changsuo*, 2001), Jia's first foray into digital filmmaking, makes poetry from everyday observation, heightening quotidian detail into a dense, suggestive portrait of a society. Collected over a period of forty-five days in the small mining town of Datong, Jia's thirty shots of anonymous travelers in a train station, transportation workers, a man in a wheelchair in a dance hall, a beautiful woman in heels running after a bus that won't stop for her slowly coalesce into a group portrait of provincial desolation and ennui. The title refers to the spaces Jia sought out, places of transit or consumption (a disused bus transformed into a restaurant combines the two) in which the private worlds of Datong's inhabitants orbit each other in communal loneliness.

More free-floating and spontaneous but no less formalist than *Xiao Wu* and *Platform*, with which it loosely forms a trilogy, *Unknown Pleasures* was also shot on digital video, its blown-out skies and juddering forms all the better to capture the unmoored lives of its two teenaged protagonists. Xiao Ji and Bin Bin, part of the "birth control generation" and so "doomed to a solitary existence,"[8] in Jia's words, buzz the provincial streets of Datong on their mopeds, bored, jobless, and without ambition, chain-smoking at the fetid community center or spending listless time with women more enterprising and intelligent than they. The aimlessness of provincial teens has been a staple of international cinema at least since Federico Fellini's *I Vitelloni*,[9] but Jia's clear-eyed empathy, his mastery of atmosphere and filmic rhythm offer fresh and searching insight into the disaffected. The film's English title derives from a Joy Division album, whereas the more evocative Chinese title, *Ren Xiaoyao*, taken from Taoist philosopher Zhuangzi, means "free of all constraints," ironic in that Jia's use of long takes and real time accentuates the aura of delimitation, of impasse and imprisonment.

The World moves away from the derelict northern provinces of Jia's previous films, interweaving the stories of several

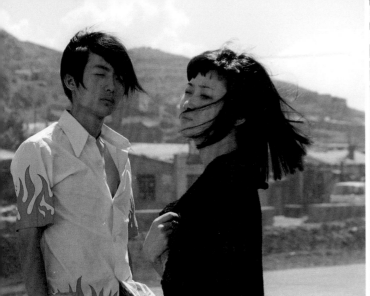
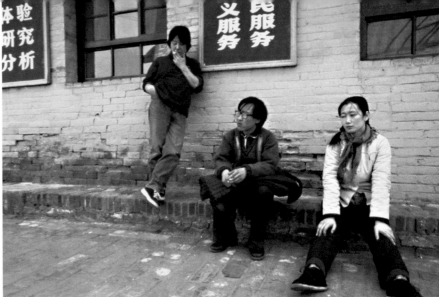

young people who work at the World Park on the outskirts of Beijing, a 114-acre stretch of detailed scale replicas of famous international landmarks. This enclosed, artificial setting provides the metaphor of forgery, fakery, and facsimile—Baudrillard goes to Beijing—that connects many of the film's teeming stories. Zhao Tao plays a dancer in the park's ethnic extravaganzas, which sample world cultures for the delectation of tourists. Her relationship with a security guard smitten with a married designer whose company does cheap fashion knockoffs (more imitation, more fraudulence) provides the central story of Jia's complex narrative, in which every subplot and aside offers another instance of loss, dashed dreams, unreciprocated love. When it was first rumored that *The World* was to be made in "the system"—that is, with the approval of the Chinese Film Bureau—many claimed that the underground radical had sold out. Some erstwhile Jia supporters have contended that the film is more conventional than his previous three, whether because of its comparatively lavish production values, its tonal sophistication, or its determinist narrative. Hardly. From its first plaintive, repeated cry, "Does anyone have a Band-Aid?," to its *Ugetsu*-like[10] ghostly final question about beginnings and endings, *The World* takes great aesthetic and political risks, as does his next film, the more subdued and concentrated *Still Life*.

"Floating population," the euphemism for the millions of Chinese who have illegally fled the impoverished countryside for the city in the hope of profiting from the "economic miracle," could be cruelly redeployed to describe the people whose

villages have been flooded for the Three Gorges Dam, their former lives literally washed away to achieve Mao's dream project. Another of Jia's odyssey-quest films, *Still Life* parallels but never overlaps two stories of search and dislocation set in Fengjie, a 2,000-year-old river city being demolished before being deluged, as if twice punished by the government in its determination to remake the countryside. Mournful and mysterious, resisting allegory as resolutely as its narrative schema courts it, *Still Life* is, even more than the decade-compressing *Platform*, about time. It is inscribed in its stately panning shots; in the drawn faces of its actors—the usually exuberant Zhao Tao, as a nurse searching for her disappeared husband, now aged into a kind of taut fatigue, and Han Sanming as a careworn coal miner; and in the landscape, its majestic mountains and misty river evoking the ancient world of scroll paintings, ironic backdrop to the now transitory city. Abject Fengjie joins Jia's other "cities of sadness," its addresses long vanished into whorls of water, its half-demolished buildings possibly toxic and crammed with itinerant workers and gangsters, its walls marked to indicate the level of imminent flooding. The eternal and the ephemeral seem interchangeable in this setting, *temps* forever *perdu* as the future arrives, in the form of a massive dam or glittering bridge, ceaseless in its ruination.

Disposable lives, throwaway traditions remain the central concern of Jia's 2007 film *Useless* (*Wuyong*), a feature-length documentary.[11] It serves as summa of the director's approach, combining as it does the three-part structure of *Xiao Wu*; the themes of globalization, fashion, and postmodernity of

Xiao Wu (Pickpocket)	Still Life	Unknown Pleasures	Platform
1997	2006	2002	2000

The World; and the Shanxi setting of many of his works.[12] Alternating slow lateral tracking shots with fixed compositions in its first third to capture the human costs of China's immense garment industry, *Useless* contrasts the factory/profit approach to making clothes—a linchpin of the country's international economy—with the aesthetic-artisanal undertaking of young designer Ma Ke. Ma's fashions are laboriously handcrafted and sometimes buried in the ground and later exhumed so that nature serves as codesigner, reflecting Ma's belief that "handmade objects are in contrast to the principles of commerce and consumption." Finding in Ma a kindred spirit, her concern with tradition, history, and aesthetics a reflection of his own, Jia follows her to Paris, where she presents her first international show. There her models are first splashed with terra-cotta clay and burdened with her voluminous cloaks—"*c'est énorme, lourd, c'est boulot!*" one model cries—before disporting themselves like so much statuary on glowing cubes and plinths in a darkened industrial space.

Jia abruptly transits from Ma's Paris exhibition to the forlorn landscape of Shanxi, and, here, in the desolate final third of *Useless*, his meanings, perhaps for the first time in his cinema, become uncertain, inadvertent even as they tend to overstatement. In a crucial moment, Ma, looking for inspiration in the hinterland, drives her sleek new car past a peasant trudging through the slag heaps with a plastic sack, which contains his trousers for mending. Whether Jia intends to suggest a callousness and solipsism in Ma's slumming in Shanxi is arguable—extra-filmic evidence suggests his total admiration for her—but this juxtaposition seems to condense so much of his disgust at the inequity and insensibility of the new China that it casts a retrospective shadow on Ma's whole enterprise. As tropes of dispensability and interment (endangered coal miners, unemployed tailors, condemned shops) accumulate in these quietly wrenching final sequences—Jia at his most watchful and empathetic—Ma's mystical prattle about the inherence of emotion and memory in her buried clothing, which she sells in her chic little Shanghai boutique, becomes in hindsight indurate, even despicable.

Though *Useless* uncharacteristically misconstrues its central point, in many ways the film sums up the first phase of Jia's career. Its plaintive, sometimes pushy score continues his use of mostly pop music as both catharsis and commentary.

Ma's fashion "happening" in Paris repeats his neo-Brechtian emphasis on performance: Jia's films are full of dances, songs, shows, magician's acts, and backwater catwalks. Most keenly, the peevish domesticity and sense of abandonment in the film's final third capture the director's tragic sense of life as an accrual of loss and injury, of broken or vanished ideals and irretrievable loves. His films can fell a viewer with their sudden release of hoarded sorrow: the pickpocket naked in a bathhouse singing his soul out, or his body sliding out of the image altogether during his final humiliation in *Xiao Wu*; Qiao Qiao doing a doleful dance after she breaks up with her boyfriend or Bin Bin being forced by a policeman to perform his favorite song in *Unknown Pleasures*; the peasant father numbly stuffing the money he has been paid for his dead son into his coat in *The World*. "Our love is strong enough to blind the world," sing Bin Bin and Yuan Yuan in a potent moment of naive hope, but their dreams, like all others in Jia, will never "rise up, just descend."

1 Jia Zhangke, interview by Valerie Jaffee, April 27, 2004, *Senses of Cinema*, http://www. sensesofcinema.com/contents/04/32/jia_zhangke.html.

2 *Pickpocket* (Robert Bresson, France, 1959).

3 Jia Zhangke, quoted in Michael Berry, "Cultural Fallout," *Film Comment*, vol. 39, no. 2 (March/April 2003), 61–4.

4 *Yellow Earth (Huang tudi)* (Chen Kaige, China, 1984). *A Man Escaped (Un condamné à mort s'est échappé)* (Robert Bresson, France, 1956). *Bicycle Thief (Ladri di biciclette)* (Vittorio De Sica, Italy, 1949). *The Boys from Fengkuei (Fengkuei-lai-te jen)* (Hou Hsiao-hsien, Taiwan, 1983).

5 Dennis Lim, "Cultural Evolution: Jia Zhangke's Lost Highways," *The Village Voice*, March 18, 2003.

6 Jia Zhangke, quoted in Kent Jones, "Out of Time," *Film Comment*, vol. 38, no. 5 (September/October 2002), 43–7.

7 *The Puppetmaster (Hsimeng jensheng)* (Hou Hsiao-hsien, Taiwan, 1993). *A City of Sadness (Beiqing chengshi)* (Hou Hsiao-hsien, Taiwan, 1989).

8 *Unknown Pleasures* press kit.

9 *I Vitelloni* (Federico Fellini, Italy, 1953).

10 *Ugetsu (Ugetsu Monogatari)* (Kenji Mizoguchi, Japan, 1953).

11 The title *Useless* derives from the name of Ma Ke's signature line of clothing, Wu Yong ("Useless" in English). The film is the second in Jia's planned Trilogy on Artists. The first, *Dong (East, 2006)*, is a portrait of the painter Liu Xiaodong, exploring the worlds of his Three Gorges and Thailand projects. Liu Xiaodong's work in *Mahjong* is shown on p. 75.

12 Jia's latest film, *24 City (Ershisi chengji, 2008)*, contemplates China's social history of the last half century by, as in *Still Life*, recounting the erasure and remaking of a symbolic locale: here, Factory 420 in Chengdu, an aeronautics and munitions plant now being demolished to make way for the eponymous complex of luxury apartments. Jia audaciously chooses a secret military site as the object of his quasi-utopian nostalgia, and interpolates several scripted interviews, including ones acted by Joan Chen and Zhao Tao, into his ostensible documentary.—The author, e-mail from the Cannes Film Festival, May 21, 2008.

Height precedes width. Page numbers refer to illustrations.

AI WEIWEI

Born 1957, Beijing. Graduated 1993, Parsons School of Design and Art, New York. Member of the artists' group Stars (*Xingxing*), 1980–82. Lives and works in Beijing.

Han Dynasty Urn with Coca-Cola Logo, 1995; clay and paint; 12 × 12 × 12 in. **frontispiece**

Whitewash, 1995–2000; installation: 132 Neolithic vases and white paint; dimensions variable, approx. 49 × 49 ft. **p. 15**

Map of China, 2003; ironwood; 57 × 77 ½ × 20 in. **p. 88**

CAO FEI

Born 1978, Guangzhou, Guangdong Province. Graduated 2001, Guangzhou Academy of Fine Arts. Lives and works in Guangzhou.

OU NING and CAO FEI
San Yuan Li, 1999; video, color, sound, 44 minutes; color photograph **p. 66**

CHANG XUGONG

Born 1957, Tangshan, Hebei Province. Member of the Yuan Ming Garden artist village, Beijing, 1994. Lives and works in Tangshan.

Dollar—Eurocurrency Series (1 $), 2003; silk embroidery on cotton; 24 × 53 in. **p. 85**

CHEN GUANGWU

Born 1967, Liuzhou, Guangxi Province. Lives and works in Beijing.

Four **Untitled** works, 1996; ink on paper; 140 × 56 in. each **p. 40**

CHEN LINGYANG

Born 1975, Zhejiang Province. Graduated 1999, Central Academy of Fine Arts, Beijing. Lives and works in Beijing.

Hanging Scroll, 1999; blood on paper; 20 ft. × 12 in. **p. 64**

CHEN SHAOXIONG

Born 1962, Shantou, Guangdong Province. Graduated 1984, Guangzhou Academy of Fine Arts. Member of Southern Artists Salon, 1986; Big Tail Elephant Group, 1991–present. Lives and works in Guangzhou.

Homescape, 2002; installation: color photographs in 9 sections; 24 × 12 × 12 in. each **p. 86**

CHEN XIAOYUN

Born 1971, Hubei Province. Attended 1991–92, China Academy of Art, Hangzhou. Lives and works in Hangzhou.

Untitled, 2003; 1 of 4 sets of 10 color photographs; 39 × 12 in. each **p. 93**

CHEN ZAIYAN

Born 1971, Yangchun, Guangdong Province. Graduated 1994, China Art Institute, Beijing. Lives and works in Yangjiang.

Three Famous Xingshu Documents, 2004; ink on paper; 44 × 140 in. **p. 98–9**

DU JIE

Born 1968, Xiangfan, Hubei Province. Lives and works in Beijing.

2003.1.15–2003.3.3, 2003; acrylic on canvas; 12 × 12 in. **p. 92**

2003.4.14–2003.5.9, 2003; acrylic on canvas; 12 × 12 in. **p. 92**

2003.5.10–2003.5.28, 2003; acrylic on canvas; 12 × 12 in. **p. 92**

FANG LIJUN

Born 1963, Handan, Hebei Province. Graduated 1989, Central Academy of Fine Arts, Beijing. Lives and works in Beijing.

Untitled, 1995; oil on canvas; 96 × 72 in. **p. 54**

Untitled, 1998; acrylic on canvas; 144 × 96 in. **p. 55**

FENG GUODONG

Born 1948, Panyu, Guangdong Province. Member of the artists' group Stars (*Xingxing*), 1980–82. Lives and works in Beijing.

Guang He (Yellow River), 1979; oil on canvas; 24 × 15 in. **p. 24**

FENG MENGBO

Born 1966, Beijing. Graduated 1991, Central Academy of Fine Arts, Beijing. Lives and works in Beijing.

2007WCSSXL01 (Wrong Coding Shanshui), 2007; acrylic and VeeJet on canvas; 78 in. × 29 ft. 6 in. **p. 6–7**

Taxi! Taxi!, 1994; oil on canvas; 39 ½ × 139 ½ in. **p. 42**

GAO BROTHERS

GAO ZHEN: Born 1956, Jinan, Shandong Province. GAO QIANG: Born 1962, Jinan, Shandong Province. Live and work in Beijing.

An Installation on Tiananmen, 2000; 4 color photographs; 17 ¾ × 25 in. each **p. 119**

GENG JIANYI

Born 1962, Zhengzhou, Henan Province. Graduated 1985, China Academy of Art, Hangzhou. Member of Hangzhou Pond Society artist group, 1986. Lives and works in Hangzhou.

The Second Situation, 1987; oil on canvas; 4 parts, 67 × 52 in. each **cover**

GENG XUE

Born 1983, Jilin. Lives and works in Beijing.

Han Xizai Dinner, No. 2, 2007; installation: porcelain with glaze; dimensions variable **p. 107**

GU WENDA

Born 1955, Shanghai. Graduated 1976, Shanghai School of Arts and Crafts; 1981, China Academy of Art, Hangzhou. Lives and works in Shanghai and New York.

Myths of Lost Dynasties, 1999; ink on paper; 126 × 80 in. **p. 62**

GUANG TINGBO

Born 1938, Dalian, Liaoning Province. Graduated 1987, Lu Xun Academy of Fine Arts, Shenyang. Lives and works in Shenyang.

I Graze Horses for My Motherland, 1973; oil on canvas; 51 × 112 in. **p. 21**

My Name Is P.L.A. (Lei Feng), 1973; oil on canvas; 60 × 38 in. **p. 36**

HAI BO

Born 1962, Changchun, Jilin Province. Graduated 1984, Fine Art Institute of Jilin; 1989, Central Institute of Art. Lives and works in Beijing.

They Recorded for the Future, 1999; 2 photographs, 1 color, 1 black-and-white; 40 × 60 in. each **p. 59**

HE YUNCHANG

Born 1967, Yunnan Province. Graduated 1991, Art Institute of Yunnan. Lives and works in Beijing.

Untitled, 2004; color photographs from 2001 performance; 49 ½ in. × 24 ft. 4 in. **p. 100–1**

HONG HAO

Born 1965, Beijing. Graduated 1989, Central Academy of Fine Arts, Beijing. Lives and works in Beijing.

Selected Scriptures, 1995; 3 silk-screen prints; 24 × 30 in. each **p. 44**

Beijing No. 5, 1998; color photograph; 60 × 48 in. **p. 44**

HONG LEI

Born 1960, Changzhou, Jiangsu Province. Graduated 1987, Nanjing Academy of Arts, Nanjing; 1993, Central Academy of Fine Arts, Beijing. Lives and works in Changzhou.

Lotus, 1998; color photograph; 40 in. diameter **p. 64**

After Song Dynasty Painting by Li Zhongan, 1998; color photograph; 40 in. diameter **p. 64**

HUANG RUI

Born 1952, Beijing. Leader of the artists' group Stars (*Xingxing*), 1980–82; designer/founder of the Dashanzi Art District (798 Factory), 2002. Lives and works in Beijing.

Yuan Ming Yuan, 1979; oil on canvas; 27 × 24 in. **p. 24**

HUANG YAN

Born 1966, Changchun, Jilin Province. Graduated 1987, Changchun Normal Academy. Lives and works in Beijing and Changchun.

Chinese Landscape: Tattoo No. 6, 1999; color photograph; 19 × 24 in. **p. 65**

Chinese Landscape: Tattoo No. 2, 1999; color photograph; 19 × 24 in. **p. 65**

HUANG YONGPING

Born 1954, Xiamen, Fujian Province. Graduated 1982, China Academy of Art, Hangzhou. Member of Xiamen Dada artist group, 1986. Lives and works in Paris.

Six Small Turntables, 1988; mixed media; 19 × 15 × 6 in. **p. 25**

JIANG ZHI
Born 1971, Yuan-Jiang, Hunan Province. Graduated 1995, China Academy of Art, Hangzhou. Lives and works in Shenzhen and Beijing.

Fly, Fly!, 1997; video, black-and-white, sound, 5 minutes **p. 66**

KAN XUAN
Born 1972, Xuancheng, Anhui Province. Graduated 1997, China Academy of Art, Hangzhou; 2002, Shanghai University, Shanghai. Lives and works in Beijing and Amsterdam.

Looking, Looking, Looking for . . ., 2004; video, color, sound, 13 minutes
p. 66

LI SHAN
Born 1942, Lanxi, Heilongjiang Province. Graduated 1963, Heilongjiang University, Heilongjiang; 1968, Shanghai Theater Academy, Shanghai. Lives and works in Shanghai.

Rouge—Flower, 1995; silkscreen and oil on canvas; 51 × 72 in. **p. 42**

LI SONGSONG
Born 1973, Beijing. Graduated 1992, Central Academy of Fine Arts Subsidiary School, Beijing; 2002, Qinghua University Fine Arts Institute, Beijing. Lives and works in Beijing.

Wave (Jiang Qing, Wife of Chairman Mao Zedong), 2002; oil on canvas; 3 panels: 44 × 132 in. overall **p. 85**

Wonderful Life, 2004; oil on canvas; 2 parts: 102 × 78 in. overall **p. 96**

LI ZHANYANG
Born 1969, Changchun, Jilin Province. Graduated 1994, Lu Xun Academy of Fine Arts, Shenyang; 1999, Central Academy of Fine Arts, Beijing. Lives and works in Chongqing.

Opening Ceremony, 2002; painted fiberglass; 31 × 60 × 120 in. **p. 86**

LIANG YUANWEI
Born 1978, Xi'an, Shaanxi Province. Graduated 1995, Central Academy of Fine Arts, Beijing; 2004, Central Academy of Art and Design, Beijing. Lives and works in Beijing.

Piece of Life, 2008; acrylic on canvas; 56 × 48 in. **inside cover**

LIN YILIN
Born 1964, Guangzhou, Guangdong Province. Graduated 1987, Guangzhou Academy of Fine Arts. Member of Southern Artists Salon, 1985–87; Big Tail Elephant Group, 1991–present. Lives and works in Guangzhou and New York.

Safely Crossing Linhe Street, 1995; video, color, sound, 30 minutes **p. 66**

LIU JIANHUA
Born 1962, Ji'an, Jiangxi Province. Graduated 1989, Art Institute of Jingdezhen, Jiangxi Province. Lives and works in Shanghai.

Obsessive Memories, 2003; installation: porcelain, 25 figures, approx. 12 × 3 × 2 in. each; dimensions variable **p. 87**

LIU WEI
Born 1965, Beijing. Graduated 1989, Central Academy of Fine Arts, Beijing. Lives and works in Beijing.

Born 1989 in Beijing, 1995/96; oil on canvas; 60 × 120 in. **p. 56**

LIU WEI
Born 1972, Beijing. Graduated 1996, National Academy of Fine Arts, Hangzhou. Lives and works in Beijing.

It Looks Like a Landscape, 2004; digital black-and-white photograph; 120 in. × 20 ft. **p. 18**

LIU XIAODONG
Born 1963, Jincheng, Liaoning Province. Graduated 1988, Central Academy of Fine Arts, Beijing; 1995, MFA, Central Academy of Fine Arts, Beijing; 1999, MFA, University Complutense of Madrid, Spain. Since 1990, has been art director, actor, and subject in Chinese independent films. Lives and works in Beijing.

Eating, 2000; oil on canvas; 78 × 78 in. **p. 75**

LIU YE
Born 1964, Beijing. Graduated 1989, Central Academy of Fine Arts, Beijing; 1994, Hochschule der Künste Berlin. Lives and works in Beijing.

Gun, 2001–02; oil on canvas; 72 × 144 in. **p. 91**

LIU ZHENG
Born 1969, Wuqiang, Hebei Province. Graduated 1992, Hebei Normal College. Self-taught photographer. Lives and works in Beijing.

The Four Beauties, 2004; color photograph; 4 parts, 39 × 78 in. each
p. 97

LU HAO
Born 1969, Beijing. Graduated 1992, Central Academy of Fine Arts, Beijing. Lives and works in Beijing.

Recording (2005) Chang'an Street, 2005; ink and color on silk; 19 in. × 164 ft. overall **p. 78–9**

A Grain of Sand, 2003; sand and ink; ¼ × ¼ in. **back cover**

LU QING
Born 1965, Shenyang, Liaoning Province. Graduated 1989, Central Academy of Fine Arts, Beijing. Lives and works in Beijing.

Untitled, 2000; acrylic on silk; 32 in. × 153 ft. 2 in. **p. 80**

LUO BROTHERS
LUO WEIDONG: Born 1963, Nanning, Guangxi Province. Graduated 1987, Guangxi Art College, Guangxi Province. LUO WEIGUO: Born 1964, Nanning, Guangxi Province. Graduated 1987, Guangzhou Academy of Fine Arts, Guangzhou. LUO WEIBING: Born 1972, Nanning, Guangxi Province. Graduated 1997, Central Academy of Fine Arts, Beijing. Live and work in Beijing.

Untitled, 1999; collage and lacquer on wood; 48 × 96 in. **p. 120**

MA DESHENG
Born 1952, Beijing. Self-taught artist. Leader of the artists' group Stars (*Xingxing*), 1980–82. Lives and works in Paris.

Untitled, 1979–2005; 4 woodcuts on paper; dimensions variable **p. 22**

MA LIUMING
Born 1969, Huangshi, Hubei Province. Graduated 1991, Hubei Academy of Fine Arts, Wuhan. Lives and works in Beijing.

Fen-Maliuming in Geneva 1999 Switzerland, 1999; black-and-white photograph; 48 × 108 in. **p. 60–1**

MIAO XIAOCHUN
Born 1964, Wuxi, Jiangsu Province. Graduated 1986, Nanjing University; 1989, Central Academy of Fine Arts, Beijing; 1999, Künsthochschule Kassel, Kassel, Germany. Lives and works in Beijing.

The Great Wall 2000 Years Ago, 2001; black-and-white photograph; 50 × 144 in. **p. 81**

Restaurant, 2001; black-and-white photograph; 50 × 120 in. **p. 81**

OU NING
Born 1969, Guangdong Province. Graduated 1993, Shenzhen University. Organized Southwest Art Research Group. Lives and works in Guangzhou.

OU NING and CAO FEI
San Yuan Li, 1999; video, color, sound, 44 minutes; color photograph **p. 66**

QI ZHILONG
Born 1962, Hohhot, Inner Mongolia. Graduated 1987, Central Academy of Fine Arts, Beijing. Lives and works in Beijing.

Untitled, 1999; oil on canvas; 31½ × 18 in. **p. 50**

QIU SHIHUA
Born 1940, Sichuan Province. Graduated 1962, Xi'an Academy of Arts, Shanxi Province. Lives and works in Shenzhen.

Untitled, 1992; oil on paper; 44 × 65 in. **p. 38**

Untitled, 1992; oil on canvas; 72 × 144 in. **p. 39**

QIU XIAOFEI
Born 1977, Harbin, Heilongjiang Province. Graduated 2002, Central Academy of Fine Arts, Beijing. Lives and works in Beijing.

Song for the Motherland, 2004; oil on canvas; 27 × 19 in. **p. 8**

SHAO YINONG AND MU CHEN
SHAO YINONG: Born 1961, Xining, Qinghai Province. Graduated 1982, Qinghai Normal University. MU CHEN: Born 1970, Dandong, Liaoning Province. Graduated 1995, People's University of China. Live and work in Beijing.

The Assembly Hall—Changting, 2002; color photograph; 49 × 72 in. **p. 95**

The Assembly Hall—Xingguo Wenchang Temple, 2002; color photograph; 49 × 72 in. **p. 95**

SHI GUORUI
Born 1964, Shanxi Province. Graduated 1992, Nanjing Normal University. Lives and works in Beijing.

Bird's Nest Stadium, 2008; black-and-white photograph; 55 × 137 in. **p. 16**

Shanghai, China, 15–16 October 2004, 2004; black-and-white photograph; 50 in. × 14 ft. 5 in. **p. 88–9**

SHI JINSONG
Born 1969, Dangyang, Hubei Province. Graduated 1978, Hubei Academy of Fine Arts, Wuhan. Lives and works in Wuhan and Beijing.

Office Equipment—Prototype No. 1, 2004; installation: stainless steel and drawings on paper; dimensions variable **p. 101**

SHI XINNING
Born 1969, Liaoning Province. Graduated 1990, Lu Xun Academy of Fine Arts, Shenyang. Lives and works in Beijing.

Duchamp Retrospective Exhibition in China, 2000–01; oil on canvas; 39 ½ × 39 ½ in. **p. 71**

Dialogue, 2001; oil on canvas; 78 ½ × 66 in. **p. 77**

SONG DONG
Born 1966, Beijing. Graduated 1989, Capital Normal University, Beijing. Lives and works in Beijing.

Breathing, 1996; color photograph; 2 parts, 48 × 72 in. each **p. 58**

SONG TAO
Born 1979, Shanghai. Graduated 1998, Shanghai School of Arts and Crafts. Since 2004 also works collaboratively with Ji Weiyu as Bird Head. Lives and works in Shanghai.

The Moment of One Shoot Another Dead, 2004; video, color, sound **p. 66**

SUI JIANGUO
Born 1956, Qingdao, Shandong Province. Graduated 1984, Shandong College of Arts; 1989, Central Academy of Fine Arts, Beijing. Lives and works in Beijing.

Legacy Mantle (Mao Jacket), 1998; aluminum, paper, and wood; 19 × 16 × 7 in. **p. 50**

SUN GUOQI
Born 1942, Dalian, Liaoning Province. Graduated from Lu Xun Academy of Fine Arts, Shenyang. Lives and works in Shenyang and North America.

SUN GUOQI and ZHANG HONGZHAN
Divert Water from the Milky Way Down, 1973–74; oil on canvas; 72 × 124 in. **p. 21**

Chairman Mao with the New National Emblem, 1973; oil on canvas; 77 × 57 in. **p. 37**

TIAN WEI
Born 1955, Xi'an, Shaanxi Province. Graduated 1990, University of Hawaii. Lives and works in Beijing.

Mind, 2006; acrylic on canvas; 86 × 144 in. **p. 104**

WANG DU
Born 1956, Wuhan, Hubei Province. Graduated 1985, Guangzhou Academy of Fine Arts. Member of Southern Artists Salon, 1986. Lives and works in Paris.

Stratégie en chambre, 1998; installation: mixed media; dimensions variable, approx. 33 × 33 ft. **p. 10**

WANG GUANGYI
Born 1957, Harbin, Heilongjiang Province. Graduated 1984, China Academy of Art, Hangzhou. Member of North Art Group, 1984. Lives and works in Beijing.

Death of Marat, 1986; oil on canvas; 60 × 78 ½ in. **p. 26**

Untitled, 1986; oil on canvas; 60 × 51 in. **p. 28**

Materialist (Two Women), 1999; polyester and millet grains; 72 × 55 × 31 in. **p. 84**

Chanel No. 5, 2001; oil on canvas; 2 panels: 120 × 78 in. each **p. 84**

WANG JIANWEI
Born 1958, Suining, Sichuan Province. Graduated 1988, China Academy of Art, Hangzhou. Lives and works in Beijing.

Living Elsewhere, 1999; video, color, sound, 40 minutes **p. 67**

WANG JIN
Born 1962, Datong, Shanxi Province. Graduated 1987, China Academy of Art, Hangzhou. Lives and works in Beijing.

Ice Wall, 1996–2004; 3 black-and-white photographs of performances; 50 × 72 in. each **p. 47**

The Dream of China, 1997; polyvinyl and fishing string; 72 × 72 × 12 in. **p. 63**

WANG JINSONG
Born 1963, Harbin, Heilongjiang Province. Graduated 1987, China Academy of Arts, Hangzhou. Lives and works in Beijing.

Standard Family, 1996; installation: 116 color photographs; 7 × 9 in. each **p. 45**

WANG KEPING
Born 1949, Beijing. Self-taught artist. Member of the artists' group Stars (*Xingxing*), 1980–82. Lives and works in Paris.

Chain, 1979; wood; 21 × 13 × 5 in. **p. 25**

Fist, 1981; wood; 22 × 10 × 6 in. **p. 25**

Ganbu, 1979–80; wood; 8 × 10 × 9 in. **not illustrated**

WANG NINGDE
Born 1972, Liaoning Province. Graduated 1995, Lu Xun Academy of Fine Arts, Shenyang. Lives and works in Shenzhen and Guangzhou.

Some Day No. 9, 2002; black-and-white photograph; 19 × 24 in. **p. 85**

Some Day No. 11, 2002; black-and-white photograph; 19 × 24 in. **p. 85**

WANG QIANG
Born 1963, Heilongjiang Province. Graduated 1991, Central Academy of Fine Arts, Beijing. Member of Northern Wilderness Printmaking group, 1981. Lives and works in Beijing.

Untitled (Mao Coat), 1998; oil on textile; 60 × 20 in. **not illustrated**

Untitled (Chinese textile blazer), 1998; oil on textile; 24 × 20 in. **p. 50**

WANG QINGSONG
Born 1966, Hubei Province. Graduated 1991, Sichuan Academy of Fine Arts, Sichuan. Lives and works in Beijing.

Past, **Present**, **Future**, 2001; color photograph; 3 parts: 51 × 84 in.; 51 × 62 in.; 51 × 84 in. **p. 82–3**

WANG XINGWEI
Born 1969, Shenyang, Liaoning Province. Graduated 1990, Shenyang Normal University. Lives and works in Shanghai.

History of Revolution, 1997; oil on canvas; 3 panels: 51 × 144 in. overall **p. 51**

WENG FEN
Born 1961, Hainan Province. Graduated 1985, Guangzhou Academy of Fine Arts, Guangzhou. Lives and works in Haikou.

On the Wall—Haikou (6), 2002; color photograph; 49 × 62 in. **p. 94**

On the Wall—Guangzhou (II), 2002; color photograph; 49 × 67 in. **p. 94**

Bird's-Eye View New Beijing, 2007; color photograph; 49 × 66 in. **not illustrated**

WU YUNHUA
Born 1944, Heilongjiang Province. Graduated 1968, Lu Xun Academy of Fine Arts, Shenyang; 1987, Central Academy of Fine Arts, Beijing. Lives and works in Liaoning Province.

From the Tiger's Mouth, 1971; oil on canvas; 87 × 79 in. **p. 20**

XIE NANXING
Born 1970, Chongqing, Sichuan Province. Graduated 1996, Sichuan Academy of Fine Arts. Lives and works in Beijing and Chengdu.

Untitled (No. 1), 2006; oil on canvas; 86 × 151 in. **p. 105**

XU BING
Born 1955, Chongqing, Sichuan Province. Graduated 1987, Central Academy of Fine Arts. MacArthur Foundation Fellow, 1999. Lives and works in Beijing and New York.

Book from the Sky, 1989; woodcut; 4 books: 18 × 12 in. each **p. 25**

Himalaya Drawing, 2000; ink on Nepal paper; 48 × 140 in. **not illustrated**

XU YIHUI
Born 1964, Lianyungang, Jiangsu Province. Graduated 1989, Nanjing Academy of Arts. Lives and works in Beijing.

Boy Reading Mao Book, 1998–99; porcelain; 24 × 19 × 24 in. **p. 50**

XUE SONG
Born 1965, Anhui Province. Graduated 1988, Shanghai Drama Institute. Lives and works in Shanghai.

Shape (Red Mao), 1996; oil on canvas; 48 × 39 in. **p. 43**

Shape (Black Mao), 1996; oil on canvas; 48 × 39 in. **p. 43**

YAN LEI
Born 1965, Hebei Province. Graduated 1991, China Academy of Art, Hangzhou. Lives and works in Beijing and Hong Kong.

The Curators, 2000; acrylic on canvas; 51 × 114 in. **p. 77**

Invitation Letter to 'documenta Kassel 1997,' 1997; mixed media; 11 × 8 in. **not illustrated**

YANG SHAOBIN
Born 1963, Tangshan, Hebei Province. Graduated 1983, Polytechnic University, Hebei Province. 1991, moved to Yuan Ming Garden artist village, Beijing. Lives and works in Beijing.

Untitled, 1996; oil on canvas; 86 × 72 in. **p. 57**

YANG ZHENZHONG
Born 1968, Hangzhou, Zhejiang Province. Graduated 1990, Zhejiang Institute of Silk Technology, Hangzhou; 1993, Zhejiang Academy of Fine Arts. Lives and works in Shanghai.

Lucky Family (1), 1999; color photograph; 24 × 39 in. **p. 51**

Lucky Family (3), 1999; color photograph; 24 × 24 in. **p. 51**

YIN XIUZHEN
Born 1963, Beijing. Graduated 1989, Capital Normal University, Beijing. Lives and work in Beijing.

Washing River, 1995; 4 color photographs; 48 × 60 in. each **p. 46**

My Clothes, 1995; installation: wood, fabric, cement, and video; 12 × 24 × 17 in. **p. 66**

YIN ZHAOYANG
Born 1970, Henan Province. Graduated 1996, Central Academy of Fine Arts, Beijing. Lives and works in Beijing.

Ode of Joy, 2003; oil on canvas; 90 × 149 in. **not illustrated**

Yin Zhaoyang and Mao, 2003; oil on canvas; 80 × 120 in. **p. 90**

Tiananmen Square, 2003; oil on canvas; 90 × 149 in. **p. 91**

YU YOUHAN
Born 1943, Shanghai. Graduated 1973, Central Academy of Art and Design, Beijing. Lives and works in Shanghai.

Untitled (Mao/Marilyn), 2005; oil on canvas; 63 × 48 in. **p. 5**

Untitled (Chairman Mao), 1996; oil on canvas; 78 × 60 in. **p. 48**

Chairman Mao in Discussion with the Peasants of Shaoshan, 1999; oil on canvas; 78 × 60 in. **p. 49**

YUE MINJUN
Born 1962, Daqing, Heilongjiang Province. Graduated 1985, Hebei Normal University. Lives and works in Beijing.

Sunrise, 1999; oil on canvas; 78 × 108 in. **p. 2**

Everybody Connects to Everybody, 1997; oil on canvas; 2 panels: 48 in. × 17 ft. overall **p. 52–3**

La Liberté guidant le peuple, 1995; oil on canvas; 2 panels: 96 × 144 in. overall **p. 53**

2000 A.D., 2000; installation: painted polyester; 25 figures: 72 × 24 × 18 in. each **p. 74**

ZENG FANZHI
Born 1964, Wuhan, Hubei Province. Graduated 1991, Hubei Academy of Fine Arts. Lives and works in Beijing.

Untitled, 1997; oil on canvas; 66 × 57 in. **p. 52**

ZHAN WANG
Born 1962, Beijing. Graduated 1988, Central Academy of Fine Arts, Beijing. Lives and works in Beijing.

Artificial Rock No. 31, 2001; stainless steel; 90 × 51 × 38 in. **p. 41**

ZHANG HONGZHAN
Born 1942, Dalian, Liaoning Province. Graduated 1968, Lu Xun Academy of Fine Arts, Shenyang. Lives and works in Shenyang.

SUN GUOQI and ZHANG HONGZHAN
Divert Water from the Milky Way Down, 1973–74; oil on canvas; 72 × 120 in. **p. 21**

ZHANG HUAN
Born 1965, Anyang, Henan Province. Graduated 1988, Henan University, Kaifeng; 1993, Central Academy of Fine Arts, Beijing. Lives and works in New York and Shanghai.

Family Tree, 2000; 9 color photographs; 50 × 40 in. each **p. 92–3**

ZHANG O
Born 1976, Guangzhou, Guangdong Province. Graduated 2000, Central Academy of Fine Arts, Beijing; 2001, Central St. Martins School of Art, London; 2004, Royal College of Art, London. Lives and works in Beijing and New York.

Horizons, 2005; 21 color photographs; 40 × 36 in. each **p. 102–3**

ZHANG PEILI
Born 1957, Hangzhou, Zhejiang Province. Graduated 1984, China Academy of Art, Hangzhou. Member of Hangzhou Pond Society artist group, 1986. Lives and works in Hangzhou.

Untitled, 1988; oil on canvas; 39 1/2 × 52 1/2 in. **p. 27**

Water: Standard Pronunciation Ci Hi (Sea of Words), 1992; video, color, sound, 10 minutes **p. 66**

ZHANG XIAOGANG
Born 1958, Kunming, Yunnan Province. Graduated 1982, Sichuan Academy of Fine Arts, Chongqing. Member of Art Group of Southwest China, 1988. Lives and works in Beijing and Chengdu.

Red Child, 2005; oil on canvas; 78 × 120 in. **p. 68**

Bloodline Series, 1997; oil on canvas; 59 × 75 in. **not illustrated**

ZHAO BANDI
Born 1966, Beijing. Graduated 1988, Central Academy of Fine Arts, Beijing. Lives and works in Beijing.

A Tale of Love Gone Wrong for Pandaman, 2003; video, black-and-white, sound, 15 minutes **p. 67**

Block SARS, **Defend the Homeland**, 2003; C-print; approx. 36 × 54 in. **not illustrated**

ZHENG GUOGU
Born 1970, Yangjiang, Guangdong Province. Graduated 1992, Guangzhou Academy of Fine Arts. Lives and works in Yangjiang.

Computer Is Controlled by Pig's Brain, 2006; oil on fabric; approx. 60 × 108 in. **p. 106**

ZHOU TIEHAI
Born 1966, Shanghai. Graduated 1987, Fine Arts School of Shanghai University. Lives and works in Shanghai.

Press Conference III, 1996; gouache on paper; 114 in. × 13 ft. **p. 73**

Placebo series, 2001; airbrush on canvas; 5 paintings, dimensions variable **p. 76**

Li Bai (Tonic series), 2002; airbrush on canvas; 86 × 28 in. **p. 76**

ZHOU XIAOHU
Born 1960, Changzhou, Jiangsu Province. Graduated 1989, Sichuan Academy of Fine Arts, Chongqing. Lives and works in Changzhou and Beijing.

Parade, 2003; installation: clay figures and video; 29 ft. × 87 in. **p. 87**

ZHU JINSHI
Born 1954, Beijing. A factory worker in the 1970s, he studied after hours with older artists. Member of the artists' group Stars (*Xingxing*), 1980–82. Lives and works in Beijing and Berlin.

Bamboo Shoot, 1979; oil on canvas; 18 × 14 3/4 in. **p. 24**

ZHUANG HUI
Born 1963, Yumen, Gansu Province. Lives and works in Beijing.

June 23, 1997, Hebei Province, Handan City, PLA Regiment 5141, Fourth Artillery Squadron—Group Photograph of Officers and Soldiers, 1997; black-and-white photograph; 40 in. × 20 ft. **p. 60–1**

August 13, 1997, Hebei Province, Daming County, Jiuzhi Township, Gaozhang Village—Group Photograph of Village Residents, 1997; black-and-white photograph; 6 × 39 in. **not illustrated**

UNKNOWN ARTISTS

33 propaganda posters and woodcuts from the Sigg Collection; dimensions variable **p. 23**

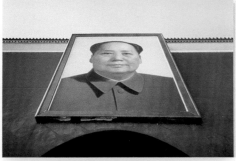

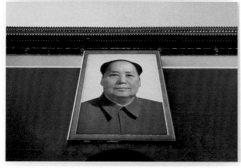

GAO BROTHERS
An Installation on Tiananmen
2000

Following page
LUO BROTHERS
Untitled (detail)
1999

ABOUT THE CONTRIBUTORS

JULIA M. WHITE is senior curator of Asian art at the Berkeley Art Museum, and former curator of Asian art at the Honolulu Academy of Arts. She is the coauthor of *Hokusai and Hiroshige: Great Japanese Prints from the James A. Michener Collection, Honolulu Academy of Arts* (1999) and *Masterpieces of Chinese Lacquer: From the Mike Healy Collection* (Honolulu, 2005), among others.

JULIA F. ANDREWS, professor of art history at the Ohio State University, is a specialist in Chinese painting and modern Chinese art. She is the author of *Painters and Politics in the People's Republic of China*, winner of the Joseph Levenson Prize of the Association for Asian Studies, and is currently working on *Art in Modern China*. She has served as exhibition co-curator and catalog author for *Fragmented Memory: The Chinese Avant-Garde in Exile* (1993), *A Century in Crisis: Modernity and Tradition in the Art of Twentieth-Century China* (1998), *Between the Thunder and the Rain: Chinese Paintings from the Opium War to the Cultural Revolution* (2000), *Sanyu, l'ecriture du corps* (2004), and *Chinese Painting on the Eve of the Communist Revolution: Chang Shu-chi and His Collection* (2006), among others.

KUIYI SHEN, professor of art history at the University of California, San Diego, is a specialist in modern and contemporary Chinese art and Sino-Japanese artistic exchanges in the late-nineteenth and early-twentieth centuries. He is the author and coauthor of many books and exhibition catalogs, including, with Julia Andrews, *A Century in Crisis: Modernity and Tradition in the Art of Twentieth Century China* (1998); *Word and Meaning* (2000); *Shanghai Modern* (2004); *The Zhou Brothers: Thirty Years of Collaboration* (2004); and *Reboot: The Third Chengdu Biennale* (2007). Born in Shanghai, he lives in California.

JAMES QUANDT is the senior programmer at Cinematheque Ontario and has edited books about Robert Bresson, Shohei Imamura, and Kon Ichikawa. He is a regular contributor to *Artforum*. Honors include the Chevalier des Arts et des Lettres from the French government for contributions to French cinema and the Special Prize for Arts and Culture from the Japan Foundation for his outstanding contribution to international cultural exchange and mutual understanding between Japan and other countries.

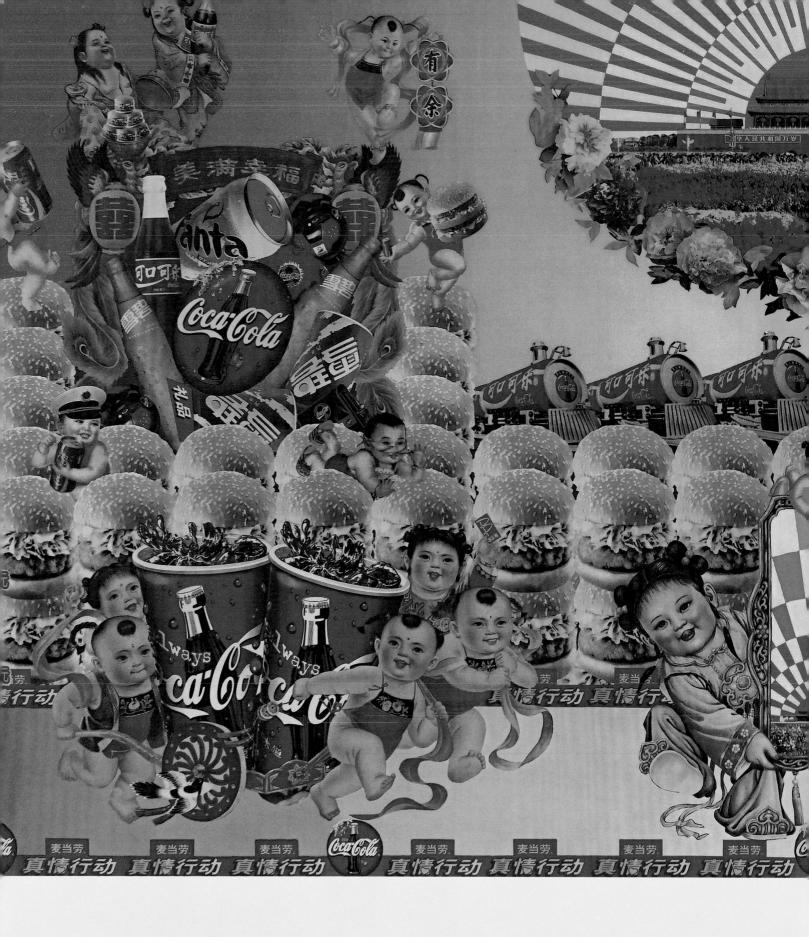